RIVER MIMRAM

TONY ROOK

AMBERLEY

Cautionary Note

When I was young, a very long time ago, I used to pretend I hadn't read the footnote in tiny italic letters on Ordnance Survey maps:

> The representation on this map of a Road, Track or Footpath is no evidence of the existence of a right of way.

I feel that there should be a similarly elegant warning at the beginning of this book. I have written about houses, gardens, parks and other things in the landscape, but the reader should bear in mind that they are private property. I have been taken to task by a local landowner because, when challenged, one of my students said something like, 'But Tony Rook sent me!'

If you are going to use this book as a guide, I recommend you buy (or borrow) the modern Ordnance Survey Explorer Maps Nos 182, 193 and 194, which cover the area. They are at a scale of two-and-a-half inches to the mile, which is ideal for walking. They show definitive public rights of way: footpaths – bridleways and other types of public access – so you'll have no excuse.

Dedicated to The Friends of the Mimram, who are doing so much to preserve the river

First published 2014

Amberley Publishing
The Hill, Stroud, Gloucestershire, GL5 4EP
www.amberley-books.com

Copyright © Tony Rook, 2014

The right of Tony Rook to be identified as the Author of this work has been asserted in accordance with the Copyrights, Designs and Patents Act 1988.

ISBN 978 1 4456 3311 4 (print)
ISBN 978 1 4456 3328 2 (ebook)

British Library Cataloguing in Publication Data.
A catalogue record for this book is available from the British Library.

Typesetting by Amberley Publishing.
Printed in Great Britain.

Contents

Introduction & Maps

If you don't attempt the impossible task of measuring along every meander and curve, the River Mimram is only about 12 ½ miles (20 km) long from its source until it meets the Lea, but its value is out of proportion to its length. It is a chalk stream, and chalk streams are very rare. They deserve protection as much as giant pandas. They are globally as important as rainforests.

Chalk streams are particularly attractive as places to live. The Mimram goes through a dozen historic parishes, and its great scenic beauty, coupled with its closeness to London has attracted many wealthy people to build country houses and to create parks along it.

What's in a Name?

To me maps are an almost endless source of entertainment. No matter how much time I spend poring over one, I always seem to be able to discover some unexpected detail as if I were looking at it for the first time. Many years ago, I had a photocopy of part of a 1766 map of Hertfordshire published by Drury & Andrews pasted directly on the wall of my study. One day, I noticed a curious fact. The road from Codicote to Wheathampstead fords a river at a place that I now know to be called Pulmer Water. Andrews (or was it Drury?) decided to label the river only at this particular place. Upstream of the ford it was the Maran River; downstream it was the Mimerum River. Arthur Young, who wrote on the agriculture of the county forty years later, tells us that the 'The Maran or Mimerum rises near Frogmore, in Hitchin Hundred'.

Then I came to live in Welwyn, through which the river flows, and found that the local authorities had, somewhat confusingly, named roads after the river: Maran Avenue, Mimram Road, Mimram Walk and Mimram Place. The poor old bumbling, mumbling Mimerum seems to have been forgotten. I was intrigued.

To confuse etymology even more, because Stevie Smith wrote a silly poem called 'River God' about a River Mimram that is nothing like the real Mimram that I know and love. Wikipedia says that 'the name Mimram is widely thought to be of Celtic origin, probably named after a Celtic god'.

Many years ago, one of my archaeologist friends, Reg Reid, pointed out that Drury & Andrews, along with other early cartographers, called the river that we today know as the Ver (a name derived from its proximity to the Roman town *Verulamium*) the Verlam or Muse. He suggested that the Celtic names for the Ver and the Mimram might come from the home of our local Belgic tribe, where there are rivers Marne and Meuse.

Places, rivers and geographical features must always have had names, but these were not written down until some educated, literate official, lawyer or map-maker needed to record

them. He would ask a local, who probably spoke an impenetrable dialect, and write down what he heard, or what he thought he ought to have heard. Thus we have Memeram, Meran, and Maeran before the Norman invasion and Mimeram around 1130. The authors of *A Dictionary of English Place Names* (who, like the cartographer and the lawyer know best) tell us that the '*correct* Old English form was *doubtless* (my italics here) "*Memere*" which may be related to "*mint*" meaning "babbling brook"', and also tell us that in Norwegian 'to babble' is *mimra* and in Danish *mimre*, but insists that the name must be English or British; an explanation that is certainly *not* as clear as a 'rattling trout stream of Hertfordshire fretting over its bed of gravel', to quote Humphry Repton, whom we shall meet later on.

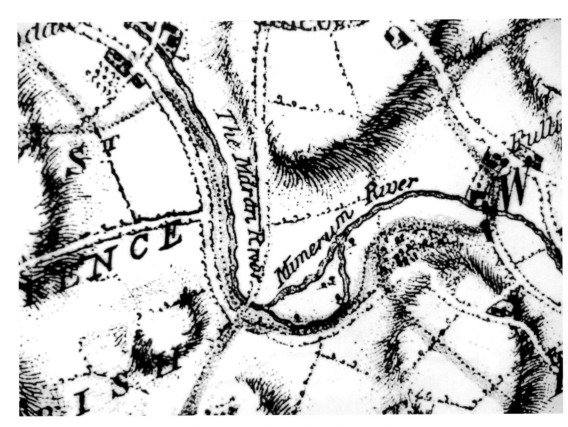

Drury & Andrews. Map showing two names for the river at Pulmer Water.

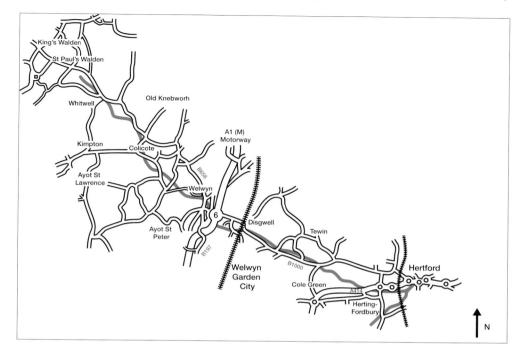

Roads in the Mimram area.

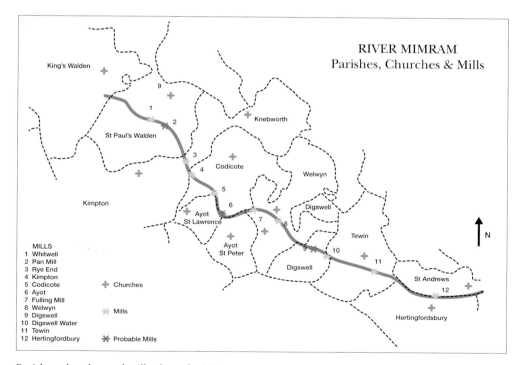

RIVER MIMRAM
Parishes, Churches & Mills

MILLS
1 Whitwell
2 Pan Mill
3 Rye End
4 Kimpton
5 Codicote
6 Ayot
7 Fulling Mill
8 Welwyn
9 Digswell
10 Digswell Water
11 Tewin
12 Hertingfordbury

✚ Churches

✴ Mills

✴ Probable Mills

Parishes, churches and mills along the Mimram.

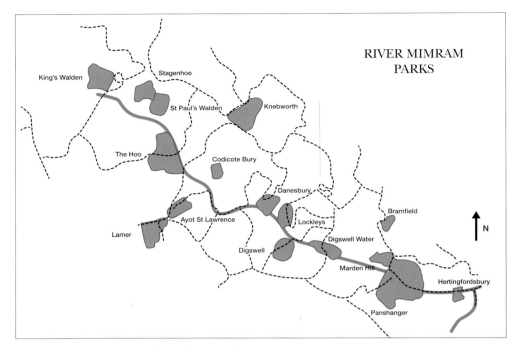

Parks along the Mimram in the mid-nineteenth century.

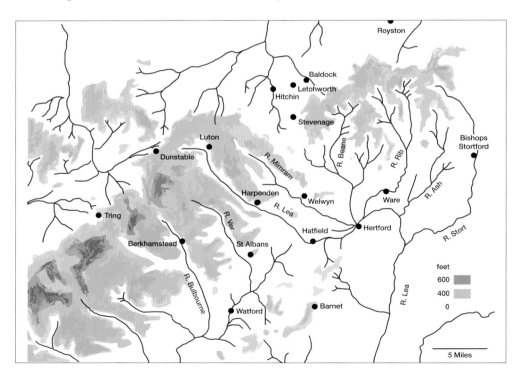

The rivers of the Hertfordshire region.

1

Early History

Natural History

Until recently, I didn't appreciate the rare nature of this river – the Mimram is a chalk stream. Why was I so ignorant? I have lived for most of my life and brought up my children in the valley of the Mimram. We played in a chalk stream and conducted an archaeological excavation beside it. I was like the man who found he had been speaking prose without knowing it.

I have paddled, waded and even pretended to swim in the chalk stream, and caught crayfish and many other sorts of freshwater fish. I have filled jam jars with strange invertebrates, watched water voles (often called 'rats'), been entertained by demoiselle flies and thrilled by kingfishers. When I was directing the excavation of the Roman villa at Welwyn, my daughters played happily and safely in the Mimram with their fishing nets.

Chalk is the soft, white rock that forms the North Downs and also lies under almost the whole of Hertfordshire. Geologists call chalk 'rock' although most of it is as soft as the *so-called* 'chalk' that teachers used (at least when I was young) to draw on blackboards.

My daughters fishing beside the excavation at Dicket Mead, Lockleys.

Chemically, chalk is calcium carbonate and was formed, mainly by chemical precipitation, from a clear sea. It sank to the bottom over a period of some 20 million years to create a layer about 300 metres (1,000 feet) thick, which now slopes upwards to the north-west to form the line of hills called the Chilterns.

It is a slightly alkaline material (some medicines taken today to cure 'acidity' contain calcium carbonate). Any gardener will know that continual manuring of the soil, particularly a sandy soil, will cause it to become acidic, or what old farmers called 'sour'. For this reason, there are depressions in the fields all over the landscape of the Mimram area where chalk was quarried, mainly to be spread on the fields. In some places there are large chalk pits where, until recently, the chalk was quarried and burned in kilns to yield 'quicklime', which, when combined with water, produced a putty-like substance – lime. Mainly, this was mixed with sand to produce mortar and plaster for building.

Rain is slightly acidic and it dissolves the products of the weathering of chalk, which are then carried in solution downstream. Unlike most rivers, chalk streams carry very little material in suspension, but they are very rich in minerals. They have been described as 'gin clear'. Their beds are composed of angular flint gravel and are usually free from fine silt and therefore ideal for fish, especially trout, to deposit their spawn. There are springs along their length, which ensure that they have relatively stable temperatures and, except when too much water is extracted from the chalk aquifer, their flow is fairly constant.

A great diversity of natural history in the floodplain results from the influence of the river, but the appearance of the valley is the result of thousands of years of farming. In modern times, much has changed, and fairly rapid changes are happening even as I write.

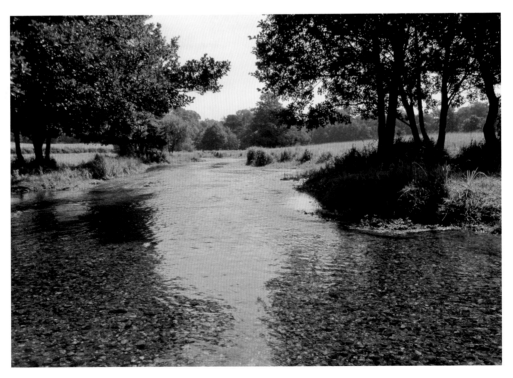

'Gin Clear'. The River Mimram near Marden.

One modern alteration has resulted from 'improvement' of meadow (grassland for mowing as hay) and pasture (grassland for grazing) by ploughing them and sowing selected grasses, which are dressed with fertilisers, selective weed killers and other agrochemicals. Perhaps more subtle have been changes in the very nature of farming. The pastures were used as rich grazing for cattle, but dairy farming has ceased. Where in my not-so-distant childhood there were draft horses, used to haul ploughs and heavy loads, we now have a different and more intense 'horseyculture', where smaller fields, usually delineated by barbed wire, are grazed by lightweight horses kept for riding. Since these horses are fed mainly with imported fodder, some of the home-grown crops have disappeared.

The part of the Mimram valley that is closest (and most approachable) to the remembered river valley of my childhood can be seen, thanks to the enlightened ownership of the Bartons and the Williams, below Tewin. The river flows through buttercup meadows, with a very rich diversity of flowers including marsh orchids. Along the river are monkey flowers (*Mimulus* or musk*)*, marsh marigolds (Kingcups), meadowsweet (*Spiraea* or Queen of the meadow), water mint (*Mentha aquatica*), brooklime, figwort, watercress, purple loosestrife … the list could go on forever. In the river are water crowfoot and, waving gently in the current, cushions of water starwort.

Water voles still survive here; they are an endangered species, threatened with extinction by imported mink. The native crayfish has been replaced by another invader, signal crayfish. There are brown trout, stone loach and bullheads (also called millers' thumbs because, it is said, their large heads resemble the tops of the thumbs the millers used to dip into their measures to cheat customers).

Water mint with butterflies at Digswell fish ponds.

Left: Purple loosestrife on
the riverbank.

Below: The Mimram from Marden
Hill bridge. *Mimulus* (monkey flower)
in blossom.

Geology

People often ask me to identify objects that they have found. I am always happy to be given the chance to have a look, even though I often have to disappoint hopeful people who think they might have found something valuable. Occasionally, someone comes up with a treasure to make it all worthwhile.

Probably the easiest objects to recognise and identify are fossils of sea creatures, such as shellfish and sea urchins, which are remarkably like those you can find on the shore today, except that they have been transformed into solid stone. 'Does that mean that Hertfordshire was once under the sea then?' my enquirers often ask. The answer is almost literally incredible: 'It was – some time ago. Your sea urchin is about 90 million years old!'

I am often brought strangely shaped nodules that sometimes resemble miniature sculptures by Henry Moore. I know they are flint, but I haven't come across a reasonable explanation for their shapes. One antiquary, many years ago, gave the unhelpful explanation that they were composed of 'fulgerous exhalations which have become conglubed'!

Flint occurs naturally in chalk. It is a very hard and brittle substance that was used by prehistoric people to make tools. How can such a strange substance come to be found in soft chalk? A clue comes from the fact that among the fossils in the chalk are those of sponges. Surprisingly, sponges are made of silica, which is the same mineral as sand. Just think of that if you use a sponge in the bath! Silica must have been present as a very dilute solution in the sea where the sponges lived, and they collected it to make their skeletons. After they died, soluble silica derived from them permeated the porous chalk. It then came out of solution again to form those weird nodules of flint that we see as distinct bands in the white cliffs of Dover.

It is the only naturally occurring material in the area that is strong enough and sufficiently weather resistant to have been used for building. It can be shaped by 'knapping', that is by striking with a hammer or a 'hammer stone', chosen because, unlike the flint, it will not shatter. You will come across knapped flint set into the mortar, made as described above, that was used to build the walls of churches.

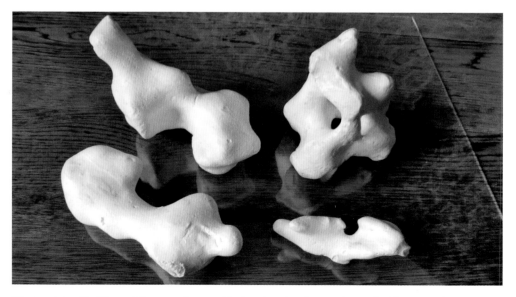

Flint nodules like Henry Moore sculptures. Their colour has been enhanced with matt paint.

Relatively thin layers of clay-rich sands and gravels were deposited on top of the chalk but, except in the south of the county, they have mostly been worn away by time. They include layers of rounded pebbles and the famous Hertfordshire puddingstone, in which the pebbles have become cemented together by silica. The last layer to be laid down was London clay, upon which the city is built.

The last great Ice Age, only a few hundred thousand years ago, altered the landscape considerably, particularly changing the pattern of the rivers, as will be described later. It also left behind another lot of gravels and another sort of clay, boulder clay, which covers much of the area to the east.

Underneath the chalk, and outcropping in parts of the county that are north of the Chilterns, is a layer of heavy grey clay with the delightful name of 'gault'. It is important because it acts rather like a damp-proof course. Rain that falls on the porous chalk soaks in and permeates down through it, eventually reaching a level where the chalk is saturated, at what is called the water table. In some places, the water table reaches the surface and flows out to form springs. This is particularly important along the north front of the Chiltern Hills, where villages, which need fresh water, occur along the spring line.

Since the movement of the water through the chalk is very slow, the water table is not horizontal; to some extent it almost follows the profile of the land surface. In valleys it is often at the surface, and chalk streams are, in a sense, the manifestation of the water table. It is difficult not to imagine that streams are flowing in impervious channels like gutters. However, during severe droughts some lengths of rivers such as the Mimram are dry, while other lengths on either side of them are still flowing.

Since many of them are tributaries of the Thames, one might expect that the rivers south of the Chilterns would flow continuously to the south-east. This is clearly not the case. When they reach the Vale of St Albans (which runs along the line from Watford to Ware) they seem to lose their sense of direction; the tributaries in the west of the county head south-west to join the Thames at Staines, and those in the east head north-east, joining the Lea (or Lee), which goes south to join the Thames near East India Docks (*see map on page 8*).

The perverse behaviour of the rivers results from the last Ice Age. Prior to this, the river that was to become the Thames flowed along the Vale of St Albans. The ice flowed from the north-east and pushed up onto the chalk hills. It divided, part of it flowing behind the Chilterns, blocking the 'proto-Thames', which formed a lake. This eventually overflowed, cutting a new channel now occupied by the modern Thames.

Prehistory

The Mimram Valley is rich in archaeological finds. Worked flints of the Paleolithic can be found on the surface of cultivated land, especially in gravelly areas. I have dug up three good examples in my garden in Welwyn village. This shows that 'finds' on distribution maps in textbooks should be treated with caution. To a great extent, they tell only where archaeologists have been active.

The Mesolithic (Middle Stone Age) is similarly distributed. I have recorded two significant sites near Welwyn. Near Fulling Mill, I found a small area of worked flint that is probably of this period, and some beautiful flint blades turned up (below water level) close to the river at Welwyn Manor House. This might be an important site in view of the possibility that waterlogged organic material might be preserved; it would be a very difficult to excavate.

I am disappointed that there are relatively few worked flints of most periods, especially of the Neolithic and Bronze Ages in the Welwyn area. The Welwyn Archaeological Society has walked up and down fields for hundreds of hours and not found many flint tools or waste

chips from making them. From the plough soil, a couple of polished stone axes represent the Neolithic. The barrow sites at Codicote and Ayot St Lawrence, however, suggest that what archaeologists call 'field walking' might produce better results on the chalk. We did find a few worked flints in excavations on Roman and medieval sites, including three beautiful Bronze Age barb-and-tang arrowheads.

2

The River at Work

Floods and Droughts

Shortly before 1700, Sir Henry Chauncy wrote of the Mimram,

> in all of which course, 'tis observable that this river never flows the Banks upon the
> greatest Rains because the dry and gravelly hills suck the Water into the Ground.

The Roman villa of which Welwyn Roman baths were a part was under a school football field. During the summer (when there were no football fixtures), we had to adopt a special timetable for digging. The sacred turf had to be kept alive, so I decided that each of our trenches should be open for only ten days. We were amateurs and therefore did most of our careful scraping at weekends. The turf could be safely kept alive for a couple of weeks or so. We started work on Friday evening (there was light enough until late). We removed the turf for a 20-foot by 10-foot trench and stacked it on polythene sheets. Two feet of soil was then excavated and heaped onto the polythene. The process was reversed the following Sunday week. In other words, we must have shifted about fifteen tons of soil on Friday evening. This mammoth task was possible for three reasons: I had lots of volunteers, we were all young and fit, and the soil was a well-drained, stone-free, grey silt.

Under the silt and on top of the Roman building rubble there was a thin, dark layer of soil, which contained, among other things, sherds of pottery with cream and brown slip-trailed decoration, and pieces of a broken wine bottle of a characteristic eighteenth-century shape. I deduced that at one time the Roman remains must have been just below turf. This had been buried under 2 feet of silt left by a catastrophic flood around 1790. One of the team found this report for me from the 1795 *Welwyn Parish Magazine*:

> Feb, Sunday 28. There was very hasty thaw and flood: and in the middle of Monday night following; Welwyn town was overflowed by the River (Mimram); and the houses in the lower rooms were flooded four and some near five feet deep in water.
>
> At the bridge, a chimney was drove down, and another damaged so much as it was obliged to be propped from falling, and part of the room and some things in it were carried away down the river to the Mill.
>
> The water ran along the Turnpike road, by the houses thro' the Rectory Farmyard into the Mill-Lane, driving away the pales as it went along, and carried away the Miller's outer offices, passing thro' the house, threatening destruction to that and the Mill; and two horses were near being drowned in the Miller's stable, but were saved by two men going up to their arms in the water, who with great difficulty got them out.

John Carrington

For the period at the end of the eighteenth and the early nineteenth centuries, we are very fortunate to have a source of information, history, legend and gossip: the diary of John Carrington, a tenant farmer who lived at Bramfield. Between 1798 and 1810 he wrote an account, on almost any piece of paper that came to hand, of events such as auctioneers' sale announcements and official instructions. This collection of papers was bound together and survived to be given to the Hertfordshire Record Office by one of Carrington's descendents, and William Branch Johnson undertook the mammoth labour of transcribing, interpreting and indexing it.

Carrington was not like most other diarists. We don't know anything about his education, and there is nothing to suggest that he wrote for posterity. He started writing after his wife died, when he was seventy-two, almost as if the written word was a substitute for chatting to her at the end of the day. For reasons that are not at all clear, he became chief constable, tax assessor, surveyor of highways and overseer of the poor. When I travel from Welwyn to Hertford and go past the turning into Welwyn Garden City, I find myself thinking that I am entering a different world, one once owned by the Cowper Family, but known intimately by John Carrington. To paraphrase Kipling: 'Whoever paid the taxes, Old John Carrington owned the land.'

I have quoted Carrington here and elsewhere in this book as accurately as I can using Branch Johnson's invaluable book *Memorandoms For...*, in which he attempted to reproduce Carrington's spelling and grammar.

Carrington wrote in his diary:

After the great frost from the 18th December 1794 to this 9th Day of February 1795, then a General Thaw and such flood for three days as ever was known in the part of the globe, and but no rain, onley the melting of the snow... [a list of bridges 'up']

Tewin River as like the River Theams, I Saw it and I wanted to Go to Cole Green from Bacon's but could not cross it on hors Back for two days... Workmen that set out on Monday morning wear they crossed the river could not git home to there fameleys till Wednesday or Thursday night following...

The Tanner's yard was filled with water and the Barn much damaged in both his barns.

The Arches, leading in off the road in and out of Lockley's Pleasure-Ground before the House were blown up, and a Gentleman's (Mr Willis Rector of Tewin) Servant lad and horse were very near being lost in the water; the lad was drove into the hedge and drawn out by the help of ropes thrown to him; but the horse, by the force of the waters, was carried far into the meadows, and obliged to be left there all the night, and with much difficulty was recovered the next day.

We are naturally concerned that some stretches of the river often dry up. This is, of course, partially because of abnormal weather conditions. One year, in the 'drowthy August weather', members of the Welwyn Archaeological Society walked dry-shod on the bed of the Mimram from Welwyn to Pulmer Water. The following winter we walked the same route on top of the river, which was frozen.

Today we blame reduced flow on the extraction of water by pumping from boreholes that go deep into the aquifer, and the fact that the demand for water increases every year as towns and industry expand. No proper strategy is in place to augment the supply or decrease wastage, and the problem gets worse.

It seems that, like global warming (or, as the Americans insist on calling it, 'climate change'), the periodic drying up of the river is not necessarily as easy to explain as we might think. Concern with reduced flow is not new. In evidence given to the House of Lords in 1904, miller Benjamin Cole said that a decline in water power for driving the mills at Kimpton and Codicote had probably begun *before* 1880, and in 1891 it had been reduced by 30 per cent. He had given up Kimpton and Codicote 'some time back' because of lack of power and trouble with fishing tenants, who then turned Codicote mill into their clubhouse. They had persuaded their landlord to release them from their lease a year ago (i.e. in 1903) *when the river went dry* (my italics).

Sir W. Beach Thomas wrote,

> In 1950 the western stretches of the Mimram … began softly and silently to vanish away. This surprising disappearance had happened before. Towards the end of the nineteenth century an official enquiry was held into the causes of the failing water, which local opinion was wont to attribute to the excessive demands of London … The essential cause was held to be the lowering of the water table … At Codicote Mill … in 1944 the water ceased even to trickle. Similar losses have been commonplace for a generation or two and a thorough investigation is called for.

Water Power

At the time of the Domesday survey in 1086, every village was almost self-sufficient and aimed to grow enough to feed itself; each village had a mill to grind its grain into flour. The mill was the property of the Lord of the Manor. Every villager was required to use the mill and the Lord took a 'toll', or 'multure', of the grain processed. Even after the breakdown of the feudal system, the miller still took it as payment.

Until the mid-nineteenth century, milling was one of the principal industries of the county, and its demise was the result of a number of factors. One of these was the lowering of the water table after the mid-nineteenth century. Water companies were blamed because they extracted water from the aquifer. The millers countered the problem to some extent by installing auxiliary steam engines. An old photograph of a mill usually shows a tall factory chimney for the boiler. Benjamin Cole said that although there was some variation caused by modern dressing of stones, a pair of 4-foot stones would grind 4 bushels of wheat per hour, using 4 horsepower. Surprisingly, it seems that the millers leased the mill but provided the steam engines at their own expense.

Steam power brought other changes in its wake. Cheap wheat was imported from abroad, particularly the prairies of the Americas, and the introduction of steam power to ships meant that transport costs were reduced by two-thirds, and imported grain was brought to local mills. The final death blow came when they realised it was illogical to bring the grain from the ports to the mills and to transport the flour away again, so large steam-powered roller mills were built close to the ports. The Mimram mills all ceased work in the late nineteenth or the early twentieth centuries. The importation of cereals meant that it was a less rewarding crop, but the railways brought the possibility of other uses for the land and some millers became dairy farmers.

Many of the mills were wooden, timber-framed and weatherboarded. Such structures have not usually survived. What usually remains are impressive earthworks. Millponds, which we might take for granted, weren't natural features, but had to be dug. And there are bypass channels that took overflow from the pond: the 'mill race', which took water to the mill wheel, and the 'tail race', which took water back from the wheel into the main stream.

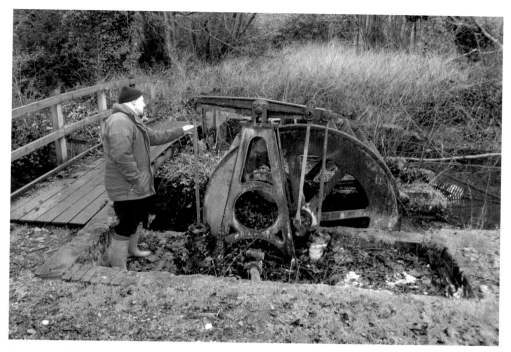

Panshanger. Water-driven force pump (hydraulic ram).

Water power was also used to supply water to the large houses along the river using water-powered pumps, often called 'hydraulic rams'. Weirs that were constructed across the river and the water in a bypass channel turned a waterwheel. A simple crank then worked a pair of force pumps. An air-filled chamber served as a shock absorber, which prevented damaging fluctuations ('water hammer') in the supply pipe. I have found these pumps at Tewin Water and Marden Hill. There are three in Panshanger Park, where two small ones have horizontal pumps worked directly from the axle of the waterwheel; the third, much larger, has vertical pumps connected to the wheel by a rocker arm.

To research other uses of the river would be an enormous but fascinating undertaking. Fishing and eel-catching are well known and, until the river flow became unreliable, trout were bred and fly fishing licences were issued. Watercress cultivation is mentioned elsewhere. Willows were pollarded or coppiced for basket- and hurdle-making, and several coppiced willow osier beds are noted on early maps. The pollarded willows of my childhood seem to have disappeared. There were rope spinners on the hillside at Fulling Mill. Did they originally use home-grown fibres?

A simple idea that doesn't occur to many people is that we don't actually *use* water as we do many other things. It is not destroyed but is available to be recycled. At New Mill End, on the River Lea, Luton's sewage is processed and the water is returned to the river, which is why the Lea doesn't dry up. Unfortunately, most of the water from the aquifer that should feed the Mimram is extracted and, after being 'used', goes into sewers that take it down the valley and out of our area, and none of the local authorities could tell me where it is processed. It is less than 200 years since Welwyn had no main drainage or sewage processing, and the medical officer for the Sanitary Authority wrote, 'The Bed of the river

between the bridge and the mill is very offensive when the mud, which has not been cleaned out since the sewage was deposited there, is exposed.' The Rector of Welwyn, imitating the Pope, had summer quarters on Hobbs Hill.

My own research suggests a shocking picture at Welwyn. When I came to Welwyn there was a disused privy at what had been, until 1919, a pub called the Queen's Head Inn. The seat jutted out over the river, which had been used upstream by cows and for dipping sheep. Further down the river, near the Wellington, there was a tannery, where leather would have been treated in vats with lime, urine and dog droppings before being washed in the river. A bit further downstream, at The Green, we found lots of horn cores. Horns, still attached to parts of the skulls, were rotted in vats. This loosened the bone from the real horn, which was then used a bit like modern plastics. The horn cores, still attached to the skull bones, were thrown aside for archaeologists to find. The river then flowed on to Welwyn Brewery. The local ales must have contained plenty of body! Further downstream, river water was drunk by people at Lockleys, Digswell House, Tewin Water, and so on. Where did *their* waste go?

3

King's Walden to St Paul's Walden

King's Walden

Today, there is no river at the top end of the Mimram valley, which grows fields of barley. I like to think of this area as it looked at the end of the last Ice Age a little more than 10,000 years ago, with the white chalk bare like an unfinished relief model in plaster of Paris being shaped by freeze-and-thaw erosion. In the summer, the surface of the model flows as a white sludge, which then freezes in the winter.

According to the Victoria County History, King's Walden had both a windmill and a watermill in the fourteenth century. There is a brick tower mill (now clad in weatherboard) near Breachwood Green. Perhaps this marks the site of the earlier windmill. Today it is difficult to imagine where a watermill could have been. There is a large pumping station taking water from a borehole, which goes deep into the chalk aquifer. The significance of such establishments has great influence on the history of the river, and the people who used it were discussed earlier.

King's Walden church.

There doesn't seem to be a village at King's Walden. What strikes the visitor are the amazing hedges, all immaculately clipped, and a visit to the church is well worthwhile, especially if you can get inside it – I had difficulty in locating a keyholder. The quality of the flint knapping of the walls is particularly noteworthy. The original structure is eleventh- or twelfth-century and extensive restoration has not spoiled the feel of the place, although the nineteenth-century floor tiles are very 'in-your-face'. A pity, even if some of them were (as I was told) made by De Morgan. The piers of the colonnade are striking, especially their capitals; their bases are discordant because the floor has been lowered. The brick vestry was built as a chapel for the Hale family, and their tombs are hidden inside. There is much else to be seen and a useful leaflet is available. Why did someone paint 'Happy Christmas' on the pillars either side of the ringing chamber in French? And when?

The Bury was the home of the Hale Family, who bought the manor from the Crown in 1576. The present house is a surprise. At first it appears to be Georgian, but you can't help feeling something is not right. It was actually built in 1972, and replaced a Victorian Gothic pile. Its park is worth a visit (there is a footpath across it). It seems to be a surviving deer park, with mature and ancient oak trees standing solitary in the grass. It is clearly still being maintained by new plantings.

Further down the valley, we are going to meet villages, such as St Paul's Walden, Codicote, Digswell and Tewin, where the church is distant from the settlement. There is usually a good explanation for this. For some reason, the village has moved. At King's Walden, however, it is difficult to explain why the settlement has moved right across the valley to Breachwood Green, which doesn't have the feeling of being a village at all. It seems disorganised; higgledy-piggledy under the flight path of Luton Airport, ancient timber-framed buildings are mixed with modern ticky-tacky. It would merit a detailed study.

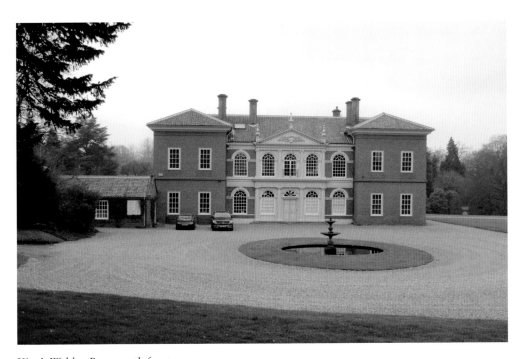

King's Walden Bury, north front.

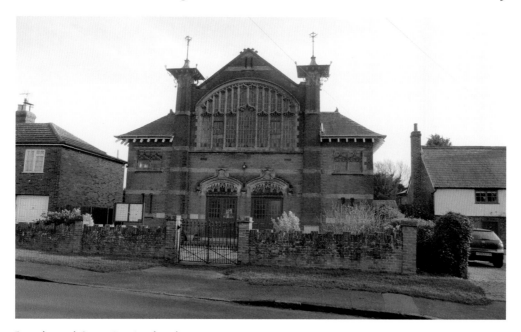

Breachwood Green Baptist church.

The most astonishing building in Breachwood Green is the Baptist chapel, a very large building in a style that might be called 'brick-built arts-and-crafts Gothic-extravagant'. It was constructed in 1904 with 'wide cornices and prominent ironmongery', according to Pevsner, and incorporates parts of a late nineteenth-century building. It is difficult to believe that a small rural hamlet could possibly have afforded such extravagance. Foundation stones tell us that important people from elsewhere contributed. A row of bricks under the windows along the west side, each neatly inscribed with names, imply that it was financed, partially at least, by a buy-a-brick scheme. Inside is a pulpit on which the date 1658 is written in ink. It is said that John Bunyan preached from it when it was in Cole Green, which is more than 10 miles away in a straight line. Another puzzle: why was it important that the pulpit was brought to Breachwood Green?

The Source

A short distance up the Mimram valley from the village of Whitwell, the Ordnance Survey optimistically marks 'springs'. Nowadays, any hopeful traveller who expects to find clear water bubbling up out of the ground will be disappointed. There are a couple of pits that are intermittently filled with water in which older local people recall swimming. Thinking that they might be naleds – holes left by melting ice after the last great glaciation – I asked geology professor John Catt to examine them. Although they must be of considerable age, since they appear on early Ordnance Survey maps, he told me that they are man-made; for what purpose we cannot tell. Further down the valley there is a dried water course, which the OS colours in blue to indicate a stream, even on their most recent maps. Today the source of the Mimram is an overgrown area of sedges, rushes and black poplars near Stagenhoe Bottom Farm, where water from the chalk seeps up, uniting into a stream in which, I am told, in living memory people used to snare pike.

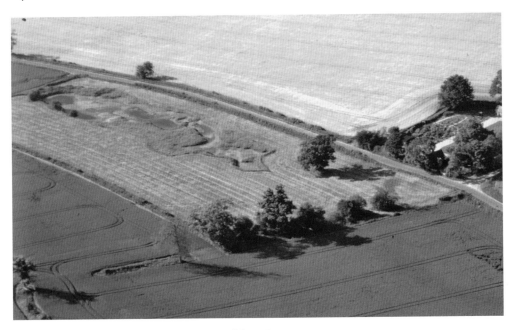

King's Walden. Alleged naleds at the source of the Mimram.

The stream passes under the road and into a channel that runs alongside the extensive Nine Wells watercress beds. Watercress is, botanically, *Nasturtium officianale*. What gardeners call Nasturtium is really *Tropaeolum*; they get other plants, such as *Syringa* (lilac) and *Pelargonium* (geranium) wrong as well. It is grown in shallow running water in rectangular beds about 2 feet deep, which are often surrounded by concrete walls. When I was a lad, we used to play tag, chasing one another along the walls of my local watercress farm. One slip and you were in ice-cold water. Worse still, of course, you might get caught by the owners.

Why does the infant Mimram not go *through* the watercress beds? Because good, reliable and uncontaminated watercress must be grown in pure water. The watercress industry was so important and profitable in the nineteenth century that nine boreholes were made, it is said, at least 200 feet into the chalk to provide it directly from the aquifer. They usually flow as artesian wells; at one time there were auxiliary pumps in case of drought. During a dry summer, a Welwyn lady told me with great authority that the river dried up because the watercress beds used too much water! The same lady also informed me, indignantly, that the river was drying up because the water company was *stealing* our water. I wonder what she thought they did with it.

The coming of the railways changed things for many rural industries. As a boy on the train to school, I attempted to travel in the guard's van. It's a place made magic by smells. Not only were there reeking paraffin oil lamps with bullseye lenses, there were milk churns clattering, boxes leaking water from fish packed in ice, and I could sit on wicker hampers (called flats), which contained watercress. There could have been no dairy industry without the railway to get the fresh milk to the customer (milking cows were once kept in the London parks and squares). Delivering sea fish and watercress to the large towns was a similar achievement.

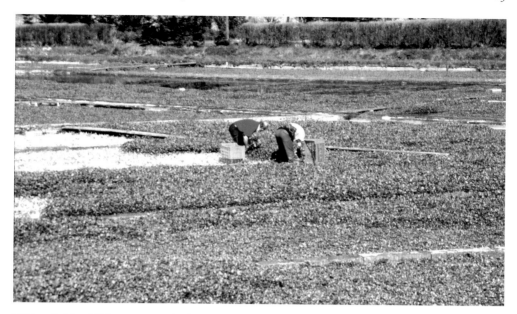

Whitwell. Nine Wells watercress beds.

Nine Wells watercress had to be taken in great quantities by cart to the railway stations at Harpenden (for carriage to Birmingham and Leeds) and Hitchin (for carriage to Cambridge, where it changed trains to go to Stratford market). In those days, at least fifteen men were employed by the growers. Today, identical twins Derek (known as Ron) and Patrick Sansom own and run the Nine Wells Watercress Farm in Whitwell, which was taken over by their grandfather some 150 years ago.

Watercress is a plant that grows easily from seeds and cuttings. It flowers when the day length reaches twelve hours. It has small, white, four-petalled flowers (the word 'cress' comes from the classification *Cruciferae*, meaning 'cross bearers'). The brothers plant every two years, sowing seed down at their other beds at Kimpton Mill, which we shall come across later. They sow the seeds on the soil in beds in which the water level is very low. The seedlings float in about an inch of water before they take root and grow. After about eight weeks, they are brought up and planted in the Whitwell beds. In the summer, a watercress bed is ready to harvest by cutting with a knife within four or five weeks of planting. Propagation, cleaning out and levelling take place at certain times of the year when watercress is prone to flowering. For the rest of the year, after the first harvest, it is allowed to regrow from the stubble and can be harvested again.

Whitwell

Whitwell is a charming place. It is not a village in the true sense, but it would be perverse to refer to it as a hamlet. The village has migrated from what was probably its original site, which is marked by the parish church. Perhaps when travel became easier and safer, the early village, now called St Paul's Walden (it was once called Abbot's Walden when it belonged to the Abbey of St Alban) moved down to the main road, and Whitwell (the place of a white well) became the dominant place. The importance of the road is attested by the number of places that provide refreshment. A dire warning is provided by a local rhyme:

Beware the *Bull* don't toss you lads,
The *Swan* don't pull you in.
The *Maiden's Head* has often led
Young people into sin.
The *Eagle's* claws are sharp and strong
The *Fox* can bite, you know.
The Little *Lamb* can buck and ram,
And the *Woodman* lay you low.

The Woodman has now disappeared but a local story tells that travellers on the old road to Bendish can hear the sound of a phantom woodman who, perhaps for working on the Sabbath, was punished like the 'Accursed Huntsman', in this case by being doomed to chop wood at night for all eternity. A similar story is told at Codicote. Whitwell adds the tale of men who were spreading soot on the fields by moonlight, for some reason. They stopped to fill their jugs at the Woodman and two locals took it into their heads to scare the soot spreaders, following them up to the field with a white sheet and chains to rattle. Apparently the jape worked and the soot spreaders fled. To give an air of verisimilitude to the story, Dr Doris Jones-Baker, who recorded the story, recounts the names and nicknames of the soot spreaders and the jokers, and even the names of the field in which the events happened. Of course we are all expected to believe that there were soot spreaders and that, like the phantom woodman, they had to work by moonlight. It's a pity that, for dramatic effect, the japers' hair didn't turn white because they actually met the ghost.

When I began my voyage down the Mimram, I was surprised that the river didn't flow through Whitwell. I was even more amazed, much later, to find that there had actually been a watermill in the village itself. There are astonishing earthworks in the fields behind the village

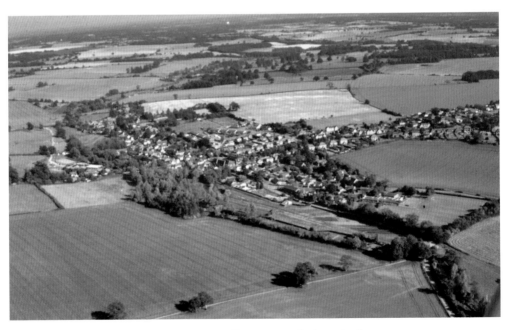

Whitwell. Aerial view from the west. Nine Wells watercress beds are in the centre.

Whitwell. The mill wheel.

that used to bring the river to it. The present course of the river marks where the overflow or bypass channel ran. The earthworks are now usually dry, and the large iron waterwheel and wheel pit, which are all that remains of the mill, are overgrown, but they and the earthworks are important industrial monuments, right beside the Chiltern Way footpath.

St Paul's Walden

St Paul's Walden does not appear to be a village today. Its principal attraction is the church, which should not be missed. It has been impeccably maintained, but has avoided the Victorian 'restoration' that has ravaged other churches we shall come upon later. Nikolaus Pevsner refers to it as 'embattled', which is an unfair term. It is, however, I would suggest, castellated or perhaps crenellated?

Legend has it that the Christians wanted to build their church close to the present St Paul's Walden Bury house, but the Devil moved the stones during the night to the opposite hill. Excavations in 1973, when the new church rooms extension was built, unearthed skeletons at the north wall of the church, which lay north–south. Christians are normally buried east–west, so it is possible that the church is on a pagan Saxon burial ground. The thickness of the north wall also suggests that it is earlier than the fourteenth-century date suggested by its windows.

The great surprises of the interior are the chancel and the extraordinary screen, which date from a remodeling in 1727 by Edward Gilbert, who was also responsible for the layout of the gardens of the Bury, which we shall come across later. There is so much more to see. A great treasure is the stained glass, which has recently been moved from the tower window to the south aisle window – it is a beautiful fourteenth-century Virgin and Child.

In the churchyard is a fine monument recording Queen Elizabeth the Queen Mother, and all her different lives. She was allegedly (the registration was manipulated) born in the Bury and she worshipped in the church here on many occasions during her life. Visitors should not miss the well house with its magnificent nineteenth-century winding gear, just outside the northern entrance to the churchyard.

My companion and I were intrigued by a plaque on the north wall of the nave, which recorded the installation of a new organ to celebrate the coronation in 1937. In 1974, a replacement organ was installed, and a smaller notice on the wall records that the other organ was moved to St Mary's, Whitwell. I had never heard of St Mary's, and Whitwell wasn't a parish. We went back to Whitwell and began a search. We had no luck until just a person in The Bull suggested a place just up the Bendish (that's a place, not a description) Road. We found it. It has been converted into a private house and there's a plaque: 'The people of Whitwell and Bendish worshipped here from 1892–1995.' I wonder – where did they worship *before* 1892? And where do they worship now? The parish church is well over a mile uphill from Whitwell, and nearly 2 miles from Bendish. And what happened to the 1937 organ?

St Paul's Walden Bury

Some years ago, I was asked to teach a course for adult classes on country houses and gardens, and I wrote to Simon Bowes Lyon asking permission to visit the garden of the Bury in order to take photographs. His hospitable reply was to come along and help myself: 'Just phone and say you're coming.'

St Paul's Walden church and the Queen Mother Monument.

One beautiful summer afternoon I had free time from my day job. I telephoned. The call was answered by a lady who took the message to say that I was coming, but when my wife and I arrived, the house was deserted. All the doors and windows were open, small dogs yapped at us, but nobody came, so we spent a couple of enjoyable hours, unchallenged, exploring.

The formal garden is most remarkable. It was probably laid out by Edward Gilbert in a style that was being replaced by the 'naturalistic' works of landscape gardeners such as Capability Brown and Repton: a series of straight allées or rides through deciduous woodland. At various places, statues or other features act as foci. You can stand by Hercules and see Diana in the distance along one allée, the octagonal organ house along another and the Bury along a third. In 1932, David Bowes-Lyon, who became president of the Royal Horticultural Society, replaced the predominantly hornbeam hedges lining the allées with beech.

Through an opening in one of the hedges, we discovered, as the designer had intended, a hidden clearing in which, on a grassy mound, stood a small *tholos* or circular temple. On the steps of the temple was a glass of champagne. It was flat, of course.

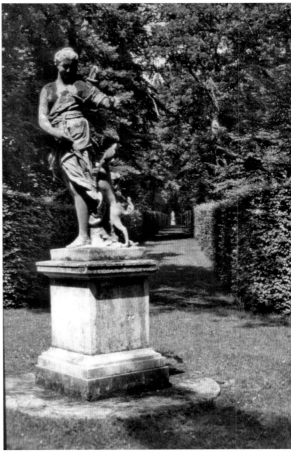

Above left: St Paul's Walden Bury, north front. (*Kris Lockyer*)

Above right: St Paul's Walden garden. Statue of Diana, with Hercules in the background.

Walden was part of the lands of the Abbey of St Alban until the dissolution. It was then owned by Richard Sturmyns, who passed it to the Dean and Chapter of St Paul's, when the name was changed. The manor house, or Bury, was sold to Edward Gilbert, who added the decorative chancel of the parish church in 1727.

St Paul's Walden Bury was the childhood home of Queen Elizabeth the Queen Mother. It was built around 1730 for Edward Gilbert. Mary Eleanor Bowes, his granddaughter, married John Lyon, the 9th Earl of Strathmore; hence the family name of Bowes-Lyon. According to the history in guidebooks, the estate has remained in the family ever since.

Further down the river, at Tewin Water, we shall come across the incredible story of an eighteenth-century lady who was kidnapped by her fourth husband, an Irishman who was a notorious duelist. It is very strange that a very similar fate befell Mary Eleanor around the same time. She was in her late twenties when she married for a second time. Her new husband was Andrew Robinson Stoney, who was a bankrupt lieutenant on half pay and had squandered the fortune inherited from his first wife. He was also an Irishman, and fought a duel with the editor of the *Morning Post* on Mary's behalf. At the time he met Mary Eleanor, she had been engaged to a Mr Grey and had very sensibly executed a deed that secured her estates to herself. Andrew did not know of this. He assumed his wife's name of Bowes and by cruelty made her sign a deed of revocation. She had two children by him and he was unfaithful.

In 1785, she escaped from him and began proceedings in the ecclesiastical court for divorce. One day she left her house in Bloomsbury Square and was abducted by a gang of men in the pay of her husband. She was hurried off to Straithland Castle. After imprisonment and brutal ill treatment, she was eventually rescued by 'some husbandmen' and taken back to London. In June 1787, Stoney, alias Bowes, and his gang were found guilty of conspiracy. He was fined £300, sentenced to imprisonment for three years and had to provide security for good behaviour for fourteen years.

Mary's Deed of Revocation to Stoney was invalidated on the grounds of duress and she was granted a divorce in March 1789. The Lord Chancellor pronounced in favour of the deed she had executed before her marriage. Lady Strathmore died at Christchurch in Hampshire in April 1800, and was buried in Westminster Abbey 'in a superb bridal dress'.

4

Stagenhoe to Codicote

Stagenhoe

Stagenhoe, the estate next to St Paul's Walden, had many different spellings in the past, but in the eleventh century it was 'Stagnehou'. One explanation of its name is that it comes from the Old English for a heel ('hoh') because it is on a spur of land. It was a very small manor at that time. The first substantial house was built there around 1650. This was destroyed by fire in 1737, and a Palladian house was built in stucco-covered brick further up the hill. In the early nineteenth century, a third, attic storey was added. Around 1866, Lord Caithness added his arms and the motto 'Commit Thy Works to God' on the pediment. Sir Arthur Sullivan lived there from 1881–89. As with most of the country houses we shall meet, it became institutionalised after the Second World War. It was a girls' boarding school from 1946–63 and became a Sue Ryder care home in 1969.

The main works of creation of a landscaped park were probably mid-1840s, when a lake was dug. The park is now arable, and the house and its grounds are very isolated.

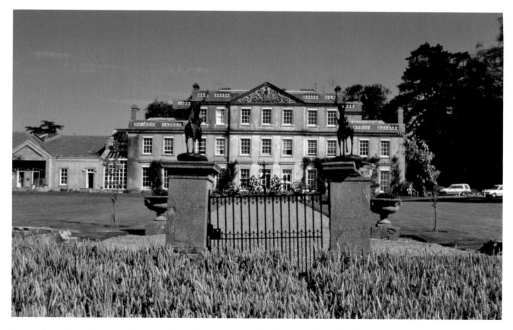

Stagenhoe from the south-west. The picture was taken from where the drive once was.

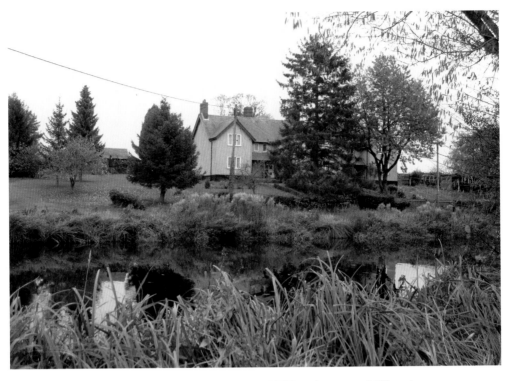

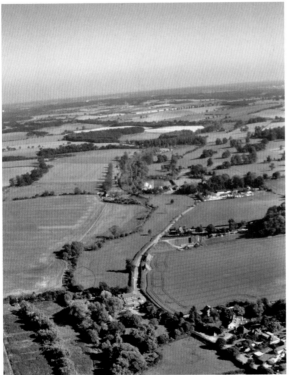

Above: Pan Mill pool.

Left: Aerial view from over Whitwell, looking south-east. Pan Mill is in the centre of the picture.

The Hoo

After it leaves Whitwell, the Mimram is closely followed by the road to Kimpton as far as Hoo Farm, where it jinks to the left and crosses the river, which is wider here. This place is called Pan Mill. The Domesday survey of 1086 records that there were two mills at St Paul's Walden, and this is a very good situation for a watermill. Apart from an artificial pool, there is no evidence, either on the ground or on maps, that there was a watermill in recent times, at least as far back as 1840.

On the right, just before the bend in the road, is a whitewashed eighteenth-century building. It must have been an early lodge for The Hoo, which we shall visit later. It has an 1870s Victorian postbox set in its front wall. After Pan Mill, the road runs past Hoo Farm and then goes between a picturesque pasture and arable hillside, which is topped by beech trees, and a neglected belt of trees called Luckswarren Wood, which was once divided from the road by a brick and flint wall, now mostly vanished. The wood was a boundary wood planned by Capability Brown when he remodeled the 100-hectare (250-acre) Hoo Park around 1760–62. The dominant trees here today, however, are black poplars, which are fairly fast growing. The park was given over to agriculture by the University of Oxford, although the many standing mature oak trees remain as evidence of its past. An ornamental bridge, designed by Sir William Chambers and constructed in brick with rusticated stone facings and a balustraded parapet, is a listed building and stands isolated on the right of the road at the next sharp bend to the left. It once carried the drive to The Hoo between an ornamental lake and a smaller pool. These have both been drained and the Mimram and the drive now miss the bridge entirely.

Beech trees and a chalk pit, opposite The Hoo.

The manor of The Hoo lay mostly to the south and west of the Mimram. Like Stagenhoe, it possibly gets its name because it is on a hoh or spur of land. It was, however, held by Eustace de Hoo in 1190. Did he take his name from the place, or was it the other way round?

The park lay between Whitwell, which is in the parish of St Paul's Walden, and Kimpton. In fact, the boundary between the parishes went through the park. Although the manor house was in St Paul's Walden, The Hoo has also in the past been called Walden Hoo and Hoo Bury. Today it is usually referred to as Whitwell Hoo or Kimpton Hoo. Owners of the manor are commemorated in both Kimpton and St Paul's Walden churches. The Hoo Lady chapel, which is sixteenth-century in date, is in the latter.

The Hoo was owned by the Hoo family until in 1665 the last of the line, Susannah, married Sir Jonathan Keate, a London Alderman, who was Sheriff of Hertfordshire. He built a new house on the site, which appears in a nineteenth-century watercolour by Buckler, now in the Hertfordshire Record Office. It is said to have had 100 bedrooms. In 1732, the manor was purchased by Margaret Brand, and in 1794 it passed to Thomas Brand, Lord Dacre. Henry Brand, the 23rd Baron Dacre, 3rd Viscount Hampden and Lord Lieutenant of Hertfordshire, was the last individual to own the property.

In 1938, he sold it to the Oxford University Chest, and it was used as offices during the war by the London & North Eastern Railway. There is a certain irony in this, as it was Lord Dacre who is said to have opposed the construction of the Great Northern Railway along the Mimram valley, and thus been instrumental in the construction of Digswell Viaduct, which we shall meet later.

The Hoo was occupied by ICI (Imperial Chemical Industries) until 1954. After ICI's departure, no tenant could be found (a theme that frequently recurs in this book) and the house was demolished. It seems odd that the stables, which are seen in Buckler's picture, survived. These have been converted into a dwelling and are now surrounded by a new estate of matching houses.

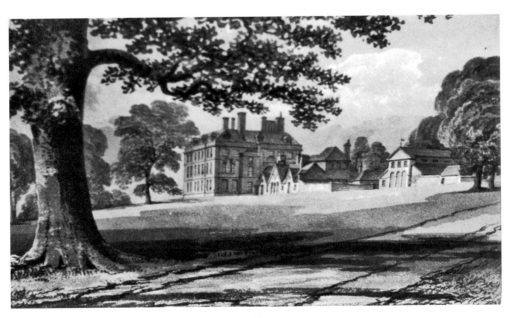

The Hoo. Nineteenth-century watercolour by Buckler.

Rye End

If, instead of following the road up a steep hill to the left, you were to follow the river and go straight along a bumpy, potholed road, you would come to Rye End. Unfortunately for anyone following the Mimram, Lord Lytton closed the main road in 1814, although you can still walk or, as I do, cycle down beside the Mimram to Kimpton Mill.

When, years ago, I was asked to talk about the history of Knebworth, I naturally read guidebooks to the town. One of the authors commented on a mystery. According to Domesday, there was a watermill at Knebworth, but there was no river. The explanation was, in fact, quite simple. Most people today think that the place they have known all their lives has been fixed since time immemorial. The present Knebworth is a relatively modern invention. One historian wrote recently about 'Knebworth, which is on the Great North Road', not realising that the present township was brought into being after the railway arrived in the mid-nineteenth century. It is therefore much more recent than the Great North Road. A lot of it was actually in the parish of Welwyn. I think that the sequence of events was similar to what happened at Digswell and, later, at Tewin, both of which we shall come to later. The church was beside the manor house and eventually the Lord of the Manor, wanting a park, moved the peasants away. In this case, hundreds of years later, people moved again or, rather, the centre of population moved to the railway station.

So, if we want to find Knebworth Mill, we should think: what did Domesday think of as Knebworth? Very few people nowadays know the boundaries of their parish. Knebworth parish is a very odd butterfly shape; the two wings come together close together near Knebworth Lodge House on the Codicote–Hitchin Road (B656). The western lobe stretches down to the Mimram at Rye End. Rye End Mill is marked on old maps. Problem solved! The wooden mill has been demolished, and what remains there is a pair of cottages. At first glance they don't seem remarkable, but a second look tells you that they would certainly repay the attention of the 'House Detectives'.

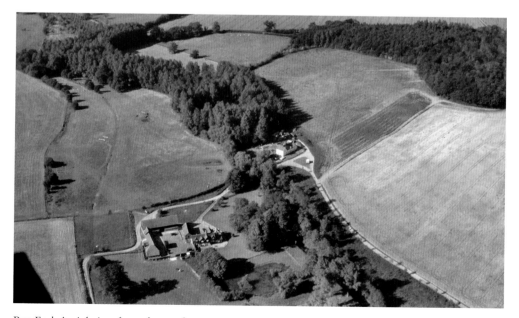

Rye End. Aerial view from the south.

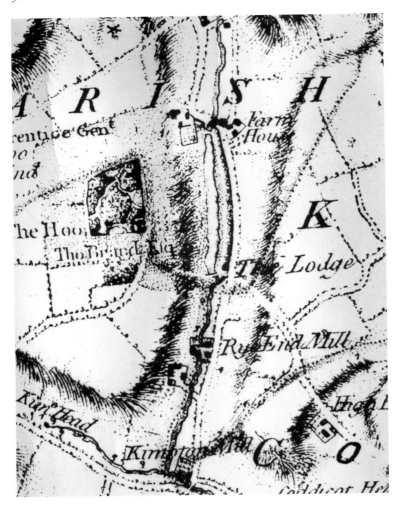

Drury & Andrews map showing Rye End Mill.

Kimpton

Kimpton Mill is less than half a mile from the site of Rye End Mill, at the confluence of the River Mimram with the River Kyme (or Kime), which Drury & Andrews' map calls 'Kyme Head'. The mill still survives, much altered and incorporating the miller's house and ancillary buildings, as a beautiful private dwelling, with the large millpond set in well-kept lawns. The surviving hydraulic engineering is fascinating. The Mimram flows at a high level past watercress beds, which are, as mentioned earlier, worked by the Sansom brothers and used as seed beds. It goes into the mill pool, save some, which is allowed to overflow into the beds. The Kyme, which is a much cleaner stream, is diverted to go round the pool beside the Mimram, which it then goes under through a large, salt-glazed pipe, to flow alongside the watercress beds. This arrangement is clearly intended to prevent the (Mimram) water in the millpond from backing up into the Kyme. Four streams of water are eventually united alongside the road behind the mill: from the Kyme, from the watercress beds, from the millpond via an overflow controlled by a sluice, which would allow the pool to be drained, and from under the house, where the mill wheel was located.

Kimpton Mill.

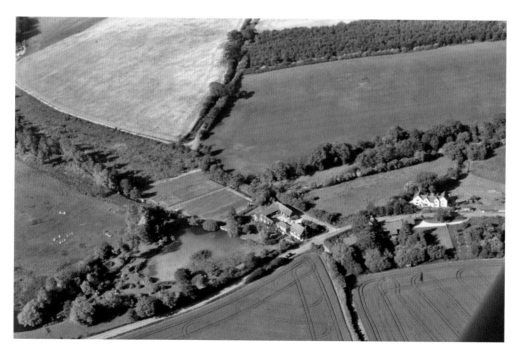

Kimpton Mill. Aerial view from the south.

The Kyme is a very short, spring-fed stream in the valley from Kimpton. It is worthwhile going up its valley, despite the presence of the sewage works immediately above the spring. As you come towards the village, there is a lovely view of the church of St Peter and St Paul standing high on the hillside on the edge of the village. It is possible that the earliest settlement moved down onto the road, but one is tempted to think that the site may have been chosen because it was already thought of as sacred before Christianity arrived.

The building of a masonry church seems to have started in the early thirteenth century, but an earlier timber structure has been suggested. There is an informative leaflet that tells the structural history and locates some objects of interest. There are fifteenth-century pews with faces carved into their 'poppy head' ends. And the screen, now separating the south chancel from the south aisle, is of the same date, and is part of the original chancel screen. Only a figure of a fifteenth-century lady with a lovely little dog survives of the eight brasses that were recorded in the early eighteenth century. There are two slabs that show the impressions of other missing brasses. Monuments include one for Sir Jonathan Keate, who built The Hoo, and one to Thomas Brand, the 20th Lord Dacre. There are other Dacre monuments in the churchyard.

The name Kimpton probably means the *tun*, or settlement, of a Saxon called Cyma. It was Chementune in Domesday. To the motorist, the present village has the feeling of being, like Whitwell, a street town – one that moved because it provided goods and services to travellers – and 100 years ago there were at least seven pubs, including The Black Horse, The White Horse, The Brewers, The Goat, The Greyhound, The Posting House, and The Boot. However, the village is worthwhile visiting; behind the High Street are snickets or alleyways that must be heavenly for children.

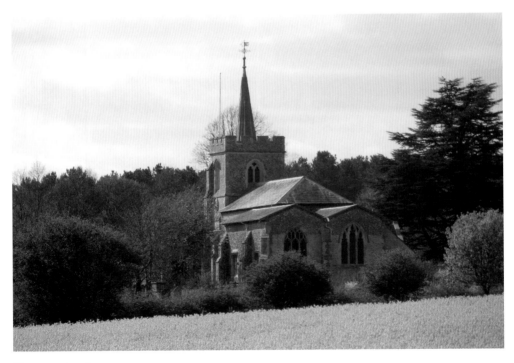

Kimpton church.

Variations in the water table cause some streams to flow intermittently or occasionally, particularly in the east of Hertfordshire. These are 'bourns' and were traditionally called 'woe waters' because their resurgence was believed to foretell some disaster such as war, plague or pestilence. Kimpton Bottom, at the west end of the village, was reputed to be a bourn. In February 2001, the legend came partially true. For the first time in living memory, the Kyme ran down the High Street for some weeks. However, there were no reported catastrophic events.

Downstream from Kimpton Mill and now mostly hidden by undergrowth are the remains of sluices and pools. These were used for breeding trout in the days when Lord Dacre rented out the stretch of river down to Codicote Mill for fly fishing. A very attractive and well maintained footpath runs down the left-hand side of the river all the way to Codicote Mill. There are some huge and ancient oak trees along it. Between the river and the Kimpton Road are luscious meadows.

Codicote Mill

According to the Domesday Book of 1086, Codicote had two mills. These were probably Codicote Mill, which we reach next on our journey down the Mimram, and Fulling Mill, which is almost in Welwyn. We shall meet it later.

When Henry VIII dissolved St Albans abbey in 1539, he sold the manor of Codicote to John Penne. The abbey's last miller was John Beste, whose widow later married John Lyon. John Lyon therefore claimed that he was the owner of the mill and that he had leased it to a miller, Richard Baker. John Penne, however, claimed that the mill was part of the demesne (the land held directly by himself as Lord of the Manor). Lyon failed to prove his claim when ordered and came to the manorial court, accompanied, according to Penne, by 'nawghty fellors … suearyng most wretchedly by God's Bloude' that he would not accept any ruling of the court and urging other tenants not to. Penne's steward tried to eject Lyon's tenant Baker but, Penne

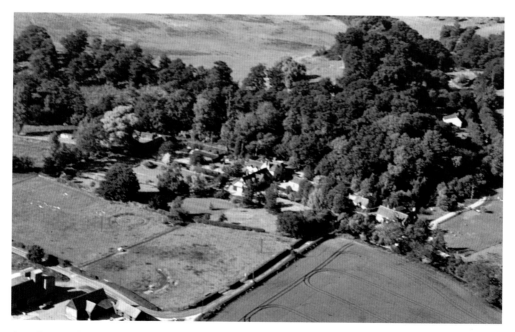

Aerial view of Codicote Mill from the south.

claimed, Lyon and others 'riotously drew their swords and made assault on the sd stuard and bet him and maltreated him in such sorte that he was in dyspeyre of his life'.

Baker's version of the story was that Penne and his servants came to the mill 'arrayed in a warlike manner, that is, to wytt, with swords, bucklers, billes, daggers and other weapons defensyble in manner of war'. They evicted Baker, his family and their goods and prepared for a siege, supplied by a 'carte wherein there was loden as welle Beddes, Breade, Beare and other like provisions … certain municions of warre as Bowes, Arrowes, handgones with gowne poudere and shote.'

After two days, Penne called the Justices of the Peace, who evicted the illegal garrison, and seized the arsenal of weapons. The 'handgones' were found to be loaded.

In the court of the Star Chamber, from the minutes of which this story has been taken, Penne declared that after his steward had been beaten, he went to the mill with the 'constable of the Towne of Coddicot without any manner of weapon save one dagger which the defendant accustomably used to weare and one small stick to walk with' and expelled Baker and installed Henry Sawyer as miller. He suggested that it was Lyon who made the warlike attack, but he was absent from Codicote and did not witness this.

Unfortunately, the written record is incomplete, and we don't know what happened to Lyon or Baker. We do know that for succeeding generations of the Pennes, the mill continued as part of their manorial possessions.

In 1894, *The Illustrated London News* described the mill as 'a long low building standing out in relief against the dark background of fir trees and a hill covered in gorse'. The hill, on the left bank of the river, was Codicote Heath. The tithe map (1837) shows a windmill here. The heath was mostly dug away in the 1950s and '60s as sand and gravel.

There was a suspected prehistoric burial mound on the heath. In 1956, it was excavated by a colleague of mine, Ernest Greenfield. Barrows are classified by their shape; this one is

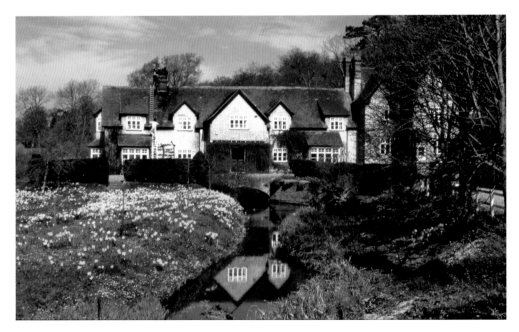

Codicote Mill.

probably a bell barrow – a mound around which was a berm and a ditch. At some time in the past, someone had dug into the mound, possibly looking for treasure, and there were small fragments of cremated bone in the soil they had put back. Beneath the undisturbed part of the mound was the original soil in which was charcoal, for which radiocarbon gave a mid-second-millennium date. Small pits contained Neolithic pottery and flints. Post holes suggested that the barrow was piled up on top of a round house or structure of Early Bronze Age date, evidenced by more than 150 sherds of pottery.

Codicote

To reach Codicote village from the mill, which is in Codicote Bottom, you have to go up a steep 'sunken way' called Heath Lane. Sunken ways, also called 'hollow ways' (Holloway in north London must have been one) were worn by repeated traffic over a very long time. A path is kept clear of vegetation and the soil is washed away as mud in winter and blown away as dust in summer. Laden carts of grain, with the skid pans under their wheels to stop them turning, must have lumbered down here, causing disastrous wear to the unmetalled road. Later, the same carts toiled back up laden with flour.

The village of Codicote was founded around AD 600. In 1002, the estate was sold by its owner, King Elfhelm, and shortly after this it passed to the Abbot and Chapter of St Albans abbey. By 1086, Domesday shows the value of the estate as £6. The Abbot's 'home farm' accounted for almost half of it. The rest was shared between a number of tenants: sixteen villeins, three humbler cottagers, one Frenchman, who may have been the bailiff, and four (landless) serfs. This suggests a total population of about 100 persons, including women and children, living on the estate.

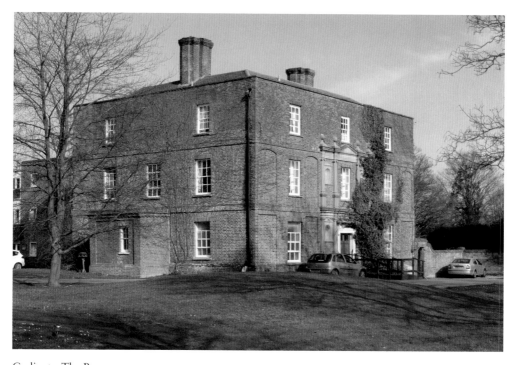

Codicote. The Bury.

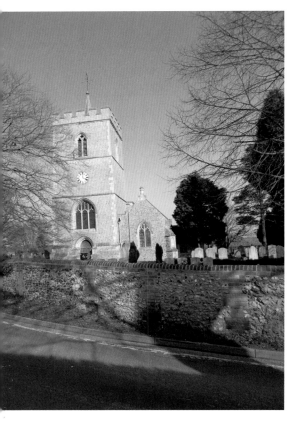 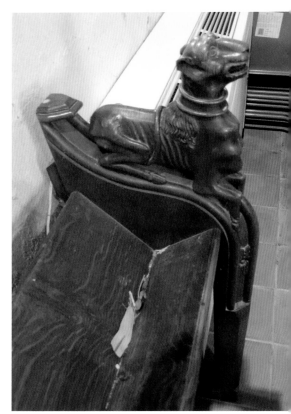

Above left: Codicote church.

Above right: Codicote church. The 'awd dawg'.

Codicote village is on the main road (B656) to Hitchin. It has had a number of pubs, some of which are still licenced: The Globe (until fairly recently the Help Me Through the World), The Goat, The Bell, and the George and Dragon, one of the oldest inns in the county, now a Chinese restaurant. Others, such as the Bull and the Plough, still stand but are no longer pubs. Unlike Whitwell, it has a wide High Street, which opens out into a broad public space. Recently, the stocks that used to be here were 'tidied away' by the council. One can imagine gallows as well. Codicote, in fact, has the characteristics of a market town. St Albans abbey was granted a weekly market here in 1267, and there survive quite detailed records of it until the Black Death in 1346, when half the population of the village perished. It was up and running again at the end of the fifteenth century, but seems to have failed after the dissolution of the abbey in 1539.

A really delicious example of the naivety and timelessness of folk stories was told to me here by a local lady. At night, she said, horses' hooves can be heard galloping away to the north, but they are under the field because that is where the Roman road used to be. The rider was a miscreant who killed somebody in an argument in the market outside Thody's fish shop. This last detail lends a certain authority to the story, as Thody was still running the shop when she told it to me. The market probably ceased in the sixteenth century.

Codicote is another village that migrated. Its parish church, St Giles, like most of the others mentioned in this book, is a little way out of town. Among the attractions of the church is 'The Old Dog'. It was probably originally a carved medieval bench end. This grotesque monster has the head of a monkey, the ears of a bat, the mane of a horse, the body of a dragon and the tail of a lion, but it has cloven hooves. To keep it from escaping, it has a carved collar and chain. To placate it, or to bring good luck, you are expected to pat its polished head. Shades of M. R. James!

There is an interesting 'bed board' memorial in the churchyard. Such memorials were common in the days before ordinary people had tombstones. They consisted of a horizontal board supported between two uprights. Being constructed of wood, most of them have perished, but this one has been repainted and restored. It records, 'In memory of John Gootheridge who died October 30th 1824 in the 79th year of his age. Reburied a week later.' The 'resurrection men', who collected cadavers for medical schools, were busy locally. When we investigated Welwyn churchyard prior to the construction of New Church House, we discovered that many of the graves had been covered by underground brick vaults in order to thwart grave robbers.

Ayot St Lawrence to Welwyn

Ayot St Lawrence

Below Codicote Mill, the Mimram takes a curved route as if it is deliberately avoiding the village, which is high above it on the left bank. This is because the river was diverted when its original valley was blocked by glacial gravel in the Ice Age. There is a ford and a small footbridge where a footpath crosses the river. This must have been an important route at one time. This is shown by the deep cutting, a sunken way leading to Codicote. On the right, however, the footpath ends at the Kimpton Road. A puzzle for the landscape historian: why is the path there?

Beyond this ford, the river today forms the boundary between the parishes of Codicote and the two Ayots: Ayot St Lawrence and Ayot St Peter. It is not clear whether these were separate villages at the time of Domesday. Place name experts tie themselves in knots over Ayot, trying to derive it from the Old English 'iggath' (pronounced 'eeyat'), which means 'a small island'. Obviously, neither of the Ayots is an island. Another explanation is that they are 'geats' (pronounced 'yats') or passes. They aren't passes either.

View from Witchcraft, showing Pulmer Water chalk pit and Nine Hills gravel pit side by side.

The Domesday survey records only one mill at Aigate. The lie of the land shows that at one time the river flowed close to the Kimpton Road and a small piece of land must have been in what is now Ayot St Lawrence. This is probably the location of the mill, which was 'in a bad state' in 1354 and 'ruinous' in 1375, after which it is not mentioned. To support the conjecture, a road called Lord Mead Lane runs down from Ayot St Lawrence to meet the Kimpton Road at the right place. One can imagine it being used to bring grain to the mill and flour back to the village,

Ayot St Lawrence was once Ayot Magna (Greater Ayot). It is a charming place, where many people come in their cars on Sundays. Its attractions include The Brocket Arms. It is also a good centre for walking. In the village is the ruin of the thirteenth-century parish church, which Sir Lionel Lyde set about demolishing in 1778. Although the bishop had the work stopped, nothing was done to repair or consolidate the ruins, which survive and are carefully maintained. Sir Lionel had commissioned Nicholas Revett, who wrote *Antiquities of Athens* and designed St Pancras church on the Euston Road (which is derived from the Erechtheion and the Tower of the Winds), to build him a new church. It is in the form of a small temple with colonnades on either side, terminating in pavilions. It is said that Sir Lionel is in one and his wife in the other, and he decreed that the Church, which had united them in life, should do him the favour of separating them in death.

Although it has no architectural merit, another great attraction in Ayot St Lawrence is Shaw's Corner. It was originally built in 1902 as a rectory but, having decided it was too big, the diocese sold it to George Bernard Shaw, who lived and worked there from 1906 until his death in 1950. He gave it to the National Trust, and it is open to the public, where you can 'follow in his footsteps'. His plays are sometimes performed in the open air in the gardens.

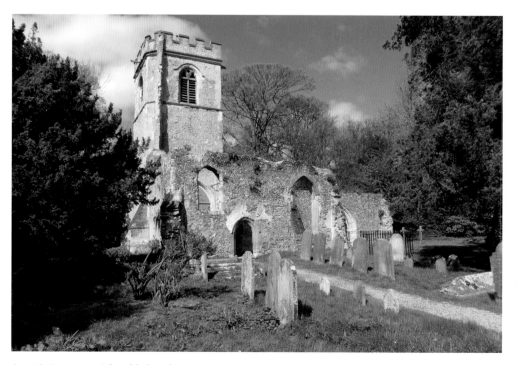

Ayot St Lawrence. The old church.

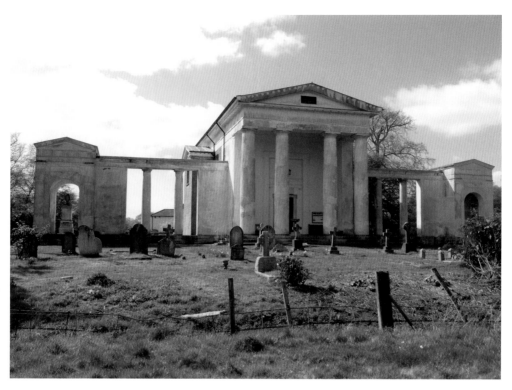

Ayot St Lawrence Nicholas Revett church. East front.

Frank Blowey, who farmed Hill Farm, Ayot St Lawrence, was flying over the area. In one of his fields, oddly enough called Witchcraft (it might originally, and less romantically, have been Wych Croft because there had been a wych elm growing there), he spotted and photographed a 'crop mark', a circle where the barley had grown shorter. He had been a member of one of my adult archaeology evening classes, and at that time he was helping my team with our excavation of the baths of the Roman villa at Dicket Mead, which we shall meet further down the river. By a remarkable coincidence, just as Witchcraft was harvested, the Welwyn Archaeological Society needed straw to protect the baths from winter frosts. Frank brought us a trailer load of Witchcraft straw, which we stuffed into polythene bags in order to put the baths to bed. We then spent the winter excavating part of the crop mark, stopping only when the site was covered in snow. There's dedication! We found a vertical-sided circular ditch cut into the chalk. It contained pottery that dated it to the end of the Neolithic period and the beginning of the Bronze Age. It also contained a polished jet ring.

From Hill Farm, you can look across the valley and imagine any number of snapshots from the past. A modern farmer flies over in a Cessna light aircraft in 1970; as a boy he watches the Mimram being straightened in the 1930s. The mill is equipped with a steam engine; it is converted into a luxury home. A literate clerk in 1837 tries to transcribe the names of the fields given him in a broad 'Arforshire' accent for the tithe survey. Four thousand years ago, Bronze Age farmers are living on Codicote Heath. Four hundred and fifty thousand years ago, the river valley is blocked by the ice. Eighty million years ago, chalk is drifting down in a clear sea.

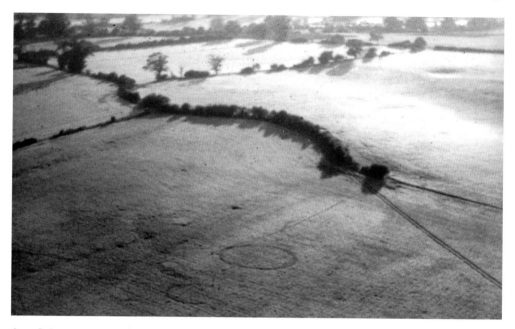

Ayot St Lawrence. Aerial view of a ring ditch at Hill Farm from the East. (*Frank Blowey*)

Ayot St Peter

The original village of Ayot St Peter disappeared in antiquity, but there is a hamlet of Ayot Green close to the Great North Road, about half a mile south of the original site. The parish has had four churches. The medieval church was demolished in 1750, and was replaced by an odd, red-brick, octagonal building with a separate tower. This was in turn replaced in 1861 by a more conventional church with a lofty spire. This in turn was struck by lightning in 1874 and destroyed by fire. The present church, a real gem, is about a quarter of a mile to the south-east of the old churchyard and beside what was the village school and is now a private house.

Pulmer Water to Singlers Bridge

Near Pulmer Water ford, a ring ditch similar to the one in Witchcraft can be seen in the crop when the conditions are right. Close to the ford, finds of Roman tiles in the plough soil suggest that there is a building of that period under the soil. After the ford, the river (remember 'Maran' and 'Mimerum' on Drury & Andrews' map?) flows almost straight for a short distance, in what is clearly an artificial course probably made at the same time that the straightening took place upstream of the ford. Old maps show two courses here; the present one is a probably a straightening of the north one. The south one, which is followed by the parish boundary between Ayot St Peter and Codicote, can still be seen as a depression, which sometimes fills with water in the field beside the Kimpton Road.

The river then meanders. On the right, in the narrow floodplain, is pasture, with steep chalk arable fields. North of the road, at the top of the fields are farms: Ryefield and Linces. South of the river are similar fields, where I remember that fifty years ago there were wide field boundaries rich in chalk flora, which have since been obliterated by ploughing. At the foot of this slope lies what is an island when the water table is high. This seems to have been

Ayot St Peter church.

planted with trees, although it does not seem to form part of any landscaping project. After about half a mile, where the river begins to rejoin its pre-glacial route towards Welwyn, the valley broadens and becomes very marshy.

The soggy nature of the valley at this point was probably exacerbated by the dam and large millpond of Fulling Mill, which is now largely silted up. The road from Kimpton avoids this marsh by making an amazingly sharp right turn up the steep hill of glacial gravel, Oak Hill, which was once quarried for sand and ballast. At one time, the road went straight on from here to join School Lane, Welwyn, at its junction with the London Road. It must then have been possible for London-bound and possibly Hertford-bound traffic to avoid Welwyn village altogether. Gill (or Gyll) Hill across Danesbury, mentioned later, must also have made it possible for Codicote traffic to avoid the village when going to the Hertford or Stevenage roads. Nowadays, the Kimpton road turns sharply left and drops down into the valley again, seemingly on a causeway, which was created when gravel was extracted from either side. On the right, it has been restored to arable. The flat-bottomed pit on the left is referred to by locals as the 'Vauxhall Testing Ground' and contains the remnants of a circular track, with various types of road surface as well as an inspection pit and gantry for lifting engines. A vague report suggests that there was a small Roman cemetery there.

The site of the millpond, leat and other works for Fulling Mill are, fortunately for the nature lover, overgrown and not easily accessible. Why Fulling Mill? 'Fulling' was one of the processes in the production of woollen cloth. After it was woven, it was trampled by

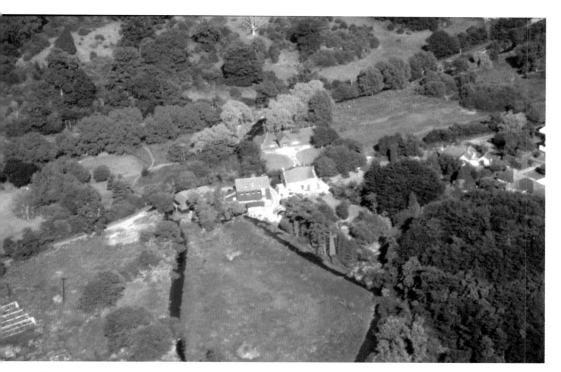

Fulling Mill. Aerial view from the south-west.

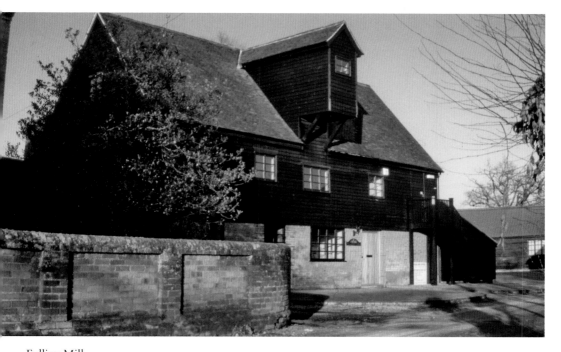

Fulling Mill.

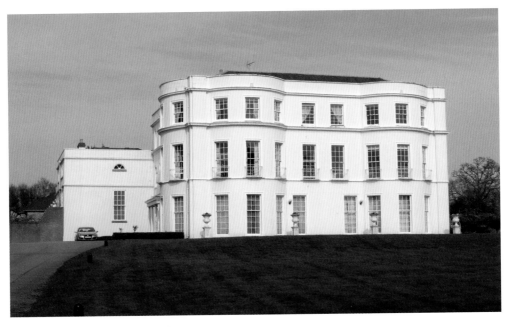

Danesbury House, from the south-west.

foot to expel oily residues and to shrink and bind it together. By the twelfth century, some mills in Hertfordshire were altered to perform this process mechanically. Fulling Mill is, surprisingly, in Codicote. John le Fuller of Codicote died of the Black Death in 1348. The last reference to fulling here was in 1601, when Thomas Martin, fuller, was buried, and the mill reverted to grinding corn by the beginning of the eighteenth century. It is now offices, but the name survives. The site of the mill wheel has been bricked up, but its position can be clearly seen, and the tail race is still visible, though overgrown. In the early nineteenth century, rope spinners had a 'walk' down the side of the hill near Fulling Mill. Rope was made by people walking backwards and twisting together long natural fibres. I wonder what fibre they used. Could it have been locally grown?

From Fulling Mill, the river flows a short way and turns sharp right (in its pre-glacial route) flowing along the side of the Codicote road. Just here you can see a sunken way that was Gill Hill, which was closed when a new drive was built to Danesbury House, built shortly after 1775 for Mary St John, wife of Capt. the Hon. Henry St John. She called it St John Lodge and created a park around it. The house was remodelled by a later owner, William Blake, in 1824 and renamed, before being sold to Barnet hospitals. It is now divided into several dwellings and joined by a mews-type development.

The river continues alongside the Codicote road. On its right is Singlers Marsh. Who (or what) was a singler? This might once have been water meadows; there is an auxiliary channel that could have been used for irrigation. Between the river and this channel, part of the marsh is convex. The esoteric explanation is that it was used in 1967 as a dump for material from the cutting made through Bonfire Hill, which connects the Codicote road to the Clock Roundabout. This might pose problems for archaeologists in the future, since the spoil contained hundreds of burials from a Roman cemetery. At the end of the marsh, the Kimpton Road passes over the Mimram at Singlers Bridge.

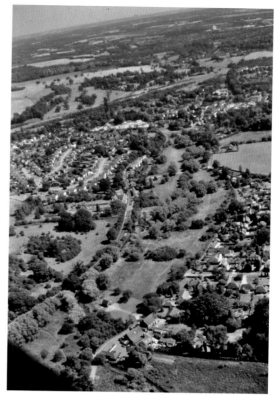

Right: Aerial view of Singlers Marsh and Welwyn from over Fulling Mill.

Below: Welwyn. St Mary's church.

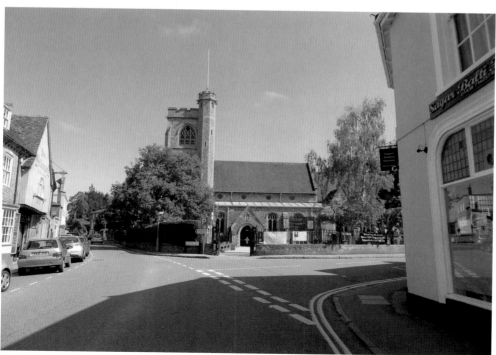

Welwyn

The village of Welwyn, which is on no account to be confused with the upstart Welwyn Garden City that stole its name, is the only village on the Mimram. It epitomises the behaviour of the best communities in guidebooks by actually nestling in the valley. It is on the line of the Roman main road from St Albans *(Verulamium)* to Colchester (*Camulodunum*). The Roman town, which must have been a posting station, lay on the west side of the River Mimram by the ford, and there was a large Roman cemetery north of the church. Two Roman villas have been discovered, and a simple suite of baths that belonged to one of them is preserved, with a small museum, in a steel vault under the A1(M) motorway. The finds from Welwyn's Roman sites are in Mill Green Museum, Hatfield.

Before the Romans settled at Welwyn, the area was occupied by the Iron Age tribe called the *Catuvellauni*, and several farms of the period have been discovered during building works on the plateau to the south-east. Astonishingly rich Iron Age burials, called 'Welwyn Type' by archaeologists, have been excavated from Prospect Place in the village and Panshanger in Welwyn Garden City, and the finds are displayed in the British Museum.

After the end of the Roman period, the road from V*erulamium* ceased to be used. Welwyn, whatever its name at the time, became unimportant, apart from one thing: it is likely that Christian worship continued there, just as it had at *Verulamium*. Christian Saxons were buried behind the present church in the seventh century, and by the tenth century there was a *monasterium* (not a monastery but a team ministry or group practice of priests ministering to the surrounding villages). When the Normans arrived in the eleventh century, a 'priest' was the lord of the small manor of Welwyn, which Domesday records as Welge. Experts suggest that this meant it was 'The Place of Willows' to the Saxons.

There is nothing to suggest that the settlement was any different from other rural and agricultural hamlets in Hertfordshire, until the seventeenth century. The introduction of coaches meant that, for the first time in history, some people were encouraged to make long journeys by road. The obvious route to take from London to the north went up the Lea valley – the route of the old Roman Ermine Street. It was churned up and crowded with traffic, bringing produce to the capital from north Hertfordshire, Bedfordshire and Cambridgeshire, and a new route was sought. There was a good road to Hatfield, where there had been a royal palace. North of Welwyn, the Roman road was still in use, although in a bad condition. Welwyn could be reached by connecting together minor roads, and the Great North Road came into being. It forded the River Lea at Lemsford Mills, came over Sherrardswood, down a track so muddy it was called Mountain Slough, into the village, down the steep hill, which is now called London Road, along the High Street and then up Church Street to join the old Roman road towards Woolmer Green.

The Romans had created a new town as a posting station on the right bank of the Mimram for the road from *Verulamium*. Now, after a gap of more than 1,000 years, a different road needed a posting station and a sleepy little hamlet on the left bank of the River Mimram became the most important town in mid-Hertfordshire. When repairs were needed for the church, an appeal for funds said, 'The town being upon the great road to London, persons of great quality often come to the church.' Changes in building style reflect the gentrification of the town. Two inns in particular, the White Hart and the Wellington, illustrate this. Each was a timber-framed house, the character of which was completely altered by being given an eighteenth-century red-brick front. Guessens, which became the rectory, was originally an untidy group of buildings constituting a farm. Its front is false, as can be seen if you look down on it from the church tower. There was an attempt to turn Welwyn into a spa.

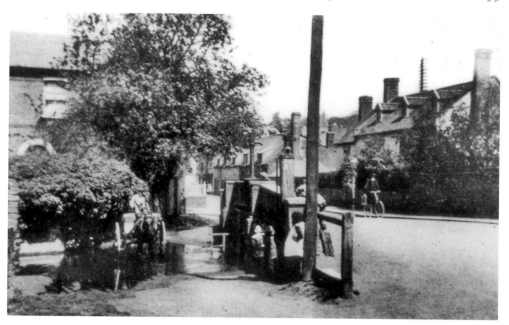

Welwyn. The ford around 1900.

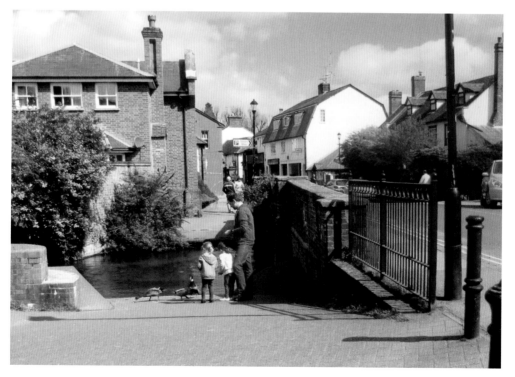

Welwyn Ford today.

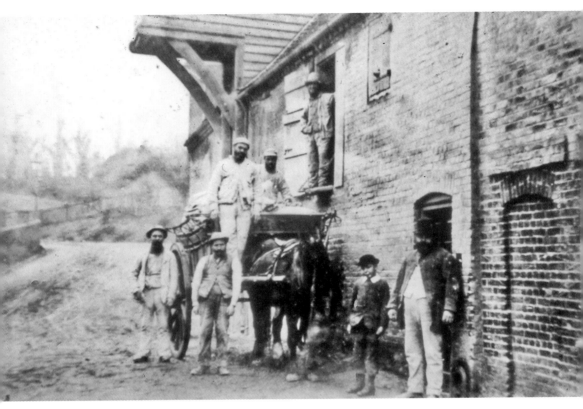

Welwyn Mill. Early twentieth-century photograph.

One significant thing happened, and it changed the very nature of Welwyn. In 1850, the railway was constructed. The obvious route would have followed the river valley, where the gradients would have been slight. However, opposition from the important landowners along the Mimram, including Lord Dacre at The Hoo, compelled the Great Northern engineers to take a line between Digswell Park, Lockleys Park and Tewin Water. They built a viaduct across the valley and dug two long tunnels. The upshot was that the railway missed Welwyn village. It also, of course, took away the coaching traffic.

After nearly 200 years of success as a posting station, Welwyn became the commercial centre of mid-Hertfordshire. It retained its importance even after the road declined. In 1900, there were at least thirty shops, a coach works, a brewery and a gasworks, as well as a dozen public houses. In 1894, Welwyn became the administrative centre of a rural district council.

The beginning of the twentieth century saw the slow introduction of motorised traffic, and use of the Great North Road once again revived. By 1920, a policeman was on point duty by the church to sort out the confusion of traffic on Church Street, going to and from Stevenage and the north, and that going on the Bedford (now Codicote) road. In 1926, Welwyn was one of the first places to have a bypass. Less than fifty years later, the Great North Road was itself bypassed by the A1(M) motorway.

Today, the almost universal ownership of motor cars, coupled with the growth of the shopping centres in the new towns, particularly Stevenage and Welwyn Garden City, has

taken away almost all the traditional retail trade from Welwyn. It is a fascinating but futile exercise to ask 'what would have happened if…?' If the railway had gone through Welwyn and the spa had been successful, might it have been another Cheltenham? If the bypass and, later, the motorway, had not been constructed, the place might have been destroyed by traffic.

As it is, the structure of its historic centre survives, and you can now walk a heritage trail created by the Welwyn Archaeological Society and, with the help of your smartphone and an app, enjoy the tours I have been leading for nearly forty years. How times have changed!

6

Lockleys to Digswell

Lockleys

Leaving Welwyn, the river flows through land, part of which was either glebe or part of the estate of Lockleys. One the left it is mainly allotments, and on the right, private housing. At the end of Orchard Road is a private house, on top of which is a curious structure like a bowler hat, which is actually a ventilator, for the building was a sewage pumping station, whereby hangs a tale.

In 1717, Edward Searle built the present Lockleys, a handsome nine-bay, red-brick mansion, after he had demolished its Elizabethan predecessor. He then decided to reroute the road that went from Welwyn to Hertford because it went past his new front door. Instead of leaving the village at the end of Church Street, the new road he created began at the White Hart. It went round his front garden, through which the Mimram flowed in two channels. The historic old Hertford Road became Lockleys Drive. A hundred years later, Sir George Shee, who then owned the house, moved part of the road a little further south, and built a new bridge over the river. It can still be seen isolated in the fields. Around seventy years later, another owner, George Edward Dering, wanted to move it even further away. To obtain permission from the Justices, he offered to provide a new sewage farm to replace Welwyn's first one, which had been opened in 1888, and which occasionally overflowed into the river (upstream of Lockleys, of course). The new road, starting at Prospect Place, was completed in 1906. The new sewage farm was on high ground to the south of it; hence the pumping station.

Starting from the east, in Lockleys Park, a very deep cutting was dug to the site of the present fire station, where it divided, one branch leading to Mill Lane and the other to the Hertford road (then known as Station Road) 100 metres east of the White Hart, where a sharp bend, built to avoid the (now vanished) gasworks, is still has to be negotiated. A light railway, with a small tank engine, was used to remove the spoil, mostly gravel. During the work, important late Iron Age burials were removed. No proper record was made, but they contained large Roman wine containers (*amphorae*), ironwork (including fire dogs), pottery and a beautiful silver cup, probably of Neapolitan workmanship. Archaeologists refer to these as 'chieftain burials', although the true status of the deceased (who was actually cremated) is not known. The most complete example was found by the Welwyn Archaeological Society sixty years later on the Panshanger housing estate in Welwyn Garden City and is reconstructed in the British Museum.

George Edward Dering deserves a book to himself. In his youth he appears to have been a genius. He was a Fellow of the Royal Society, and patented several inventions, including ones for food preservation, electric telegraphy and undersea telegraph cables. George recalled testing underwater cables in the Mimram. He advised the Electric Telegraph Company when they laid a cable across the Atlantic, and one author says that at the age of twenty-two he was

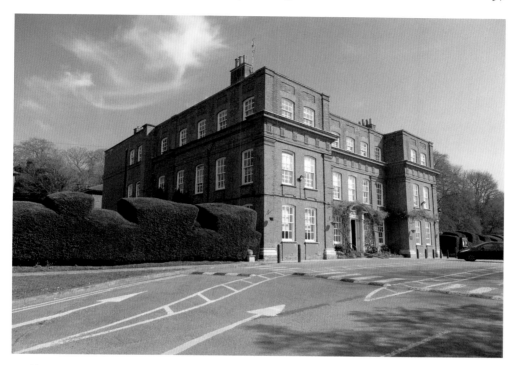

Lockleys, south front.

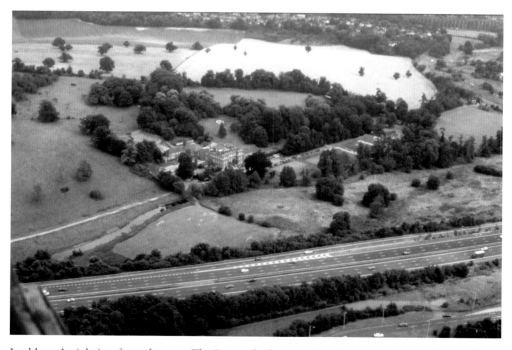

Lockleys. Aerial view from the west. The Roman baths are under the motorway near the right-hand bottom corner.

Excavation for the new Hertford road, Welwyn, in 1905.

Panshanger Iron Age chieftain burial in the British Museum.

aboard the *Reliance* under Captain Edward Hawes RN on 18 July 1852, when it laid the first lengths of cable. He also had his own foundry behind the house. Around 1880, he dismissed his workmen and went away, returning to a neglected estate at infrequent intervals until, it is said, his wife died in 1907 and he took up residence in one room of Lockleys.

After Dering died, he acquired a legendary reputation for eccentricity, which seems to have been generated by the press, and the only sources of information about his later life seem to be the usual romanticised articles written by reporters who interviewed local gossips, and which have been accepted uncritically ever since. 'He was a recluse,' we are told, who 'lived on his own'. Nonsense! I live on my own but, unlike Dering, I don't have a butler, footman, housekeeper, housemaid, kitchen maid and coachman.

One fact that seems to support the idea that he was eccentric is that after he died, it was discovered that he was married and that during the period of his absence from Lockleys he had been living in Brighton. He left Lockleys and his house in Brighton to his daughter, Rosa, wife of Alfred James Neall.

Another fact that contributes to the accusation of eccentricity is that the only surviving photograph of George Dering (and he himself said that it was the only photograph he ever had taken) was of him as a young man sitting on a tightrope over the Mimram at Lockleys. This has become part of the story that he was a friend of Charles Blondin, for which I have not been unable to find any evidence.

Dicket Mead

To the east, Lockleys estate is cut off from Welwyn today by the bypass and by the A1(M). On the hill, famed in the eighteenth century for its walnut trees (one still survives) and silver-haired rabbits, stands Derings, a house built for George Edward's grandson. In 1935, while he was planting an orchard beside the house, he discovered and began to excavate the remains of a Roman building. He was persuaded to allow what was in those days a 'proper' excavation, directed by John Ward-Perkins, who later became a well-known archaeologist.

The site was important in the study of Roman sites in Britain, as it was a villa that seems to have begun as a late pre-Roman Iron Age (Belgic) farm, the owners of which adopted the Roman way of life. There was a Roman building there at the end of the fourth century.

The words 'Roman villa site of' and 'Roman settlement' on the Ordnance Survey map of Welwyn were among the things that persuaded me to work in a small research establishment in the village in 1960. I had only been there a few days when I discovered tiles that told me a Roman site was being destroyed by work being done on the bypass. Despite finds from Welwyn being in all the local museums, as well as Cambridge Archaeological and Ethnological Museum and the British Museum, I could find no archaeologist who was capable of taking charge of rescue work on the site. I recruited a few volunteers and spent a long weekend directing the quick 'rescue dig'.

With Welwyn Garden City being developed and building and engineering work going on all around it, it seemed to me that Welwyn needed a trained team of volunteers. To train them, I needed a research excavation as a base. One afternoon I said to my wife, 'Let's go and find a Roman villa.' I put on my new wellington boots and we scrambled down the embankment of the bypass. I walked in the River Mimram, my wife in the football field of Sherrardswood School above me. After about 150 metres, I found Roman tiles projecting from the riverbank, dug a small hole in the bank and found some fine pieces of a Roman folded beaker. We went to Lockleys, the headquarters of the school, and the headmaster gave us permission to begin a small trial excavation, which eventually went on for nearly twelve years and uncovered a group of Roman buildings around a courtyard.

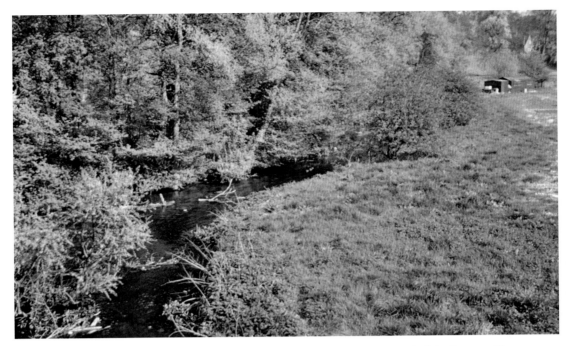

The river at Dicket Mead, looking north-west. The first building discovered of the Roman villa was under here.

The moment of discovery. Roman tiles in the river bank at Dicket Mead.

The team I brought together at this site became the Welwyn Archaeological Society, which still exists today. We explored the district, discovering several Iron Age farmsteads on building sites in Welwyn Garden City and an Iron Age *oppidum* (fortified town) at Burnham Green. In 1968, we excavated in front of the bulldozers on a new stretch of motorway near Welwyn Garden City golf course, some miles south of 'our' Roman villa site. It seemed likely that the next phase of motorway construction would threaten the villa so, for the first time, we used a machine to remove topsoil and found a well-preserved suite of Roman baths.

The motorway would be constructed on an embankment at this point. An architect friend drew a visualisation of a vault that might save the baths and it was published in *The Observer*. I started a fund to finance a campaign – I gave lectures and we held a jumble sale. The local district council expressed their support. To my surprise, the minister responsible announced that the Department for Transport 'would be prepared to treat the baths as a bridging problem' if the local people could raise the funds to open the site as a museum. This was a bluff – he didn't tell me, I read it in a newspaper. The road engineers wouldn't design the 'bridge' until I could show I had the funds necessary to fit it out as a museum, but how could I tell what funds it would need without a design? It was lucky that I had worked in civil engineering. The county council then chipped in, offering to match my fundraising. You can now visit Welwyn Roman baths, cosily preserved 9 metres under the traffic on the motorway.

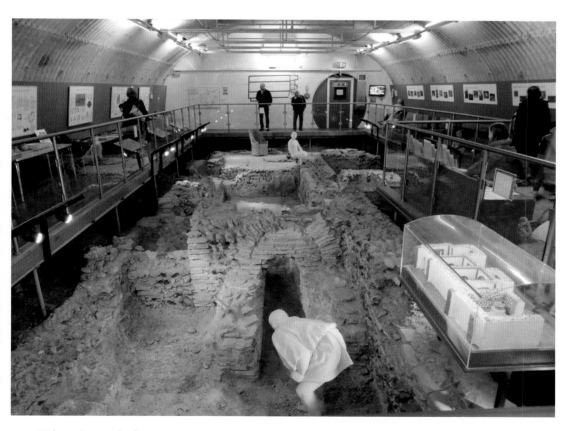

Welwyn Roman baths.

Digswell

In the cutting that George Dering made to divert it away from Lockleys, the Hertford road from Welwyn goes under the bypass and then under the motorway. It then becomes a dual carriageway, and is reunited with the Mimram, which is flowing through pastureland. On the left is a lodge to Lockleys, which was probably designed by Lutyens and was built in 1913. Then there are steep arable fields. On the right is pasture, behind which is the modern Monk's Walk School. At a roundabout, a new road to the right, Bessemer Road, leads into Welwyn Garden City.

In 1903, inspired by the idea of Ebenezer Howard that garden cities should be created to combine the benefits of both town and country, the First Garden City Company purchased around 1,600 hectares (almost 4,000 acres) of agricultural land in north Hertfordshire and began building Letchworth Garden City. Howard became frustrated when he found that this example did not inspire others, including central government. According to legend (different protagonists in the story tell different tales), he was commuting between Letchworth and London in 1919 when he saw a notice announcing that part of the Desborough estate was to be sold by auction. He bought 1,458 acres of it using money he borrowed from the auctioneers.

This land, mostly on the plateau between the Mimram and the Lea, is where Welwyn Garden City was created. It was pointed out at the time that none of it was in Welwyn, it was not a garden and it wasn't a city. Until the 1950s, none of it was in the Mimram valley, so most of it does not come within the scope of this book. An account of its construction requires a book to itself, and I have written about it myself in my *Welwyn & Welwyn Garden City Through Time*. The main impact of the new town on the Mimram valley has been the construction of new roads, the improvement of existing roads, and the excavation of 'lagoons' to allow the surface water run-off to settle.

To the right of Bessemer Road, hidden today in the Knightfield district of Welwyn Garden City, are Digswell House and Digswell parish church. Apart from a walled garden and stables, both of which have been demolished, the church and house stood alone in neglected parkland until they were swamped by the New Town in the 1960s. Digswell was yet another of the villages that moved. This time the Lord of the Manor, probably Laurence de St Michael in the late thirteenth century, created a park and destroyed the village.

A beautiful map, now in the County Record Office, shows the extent of the estate in 1599. The manor house is shown in great detail as if seen from the air. There were two courtyards, each with its own gatehouse. One was bounded by the house with an extension wing, the other was a farmyard with barns and a well house. Attached were a walled orchard and an enclosure for the church; the whole complex being 8 acres in extent according to a contemporary survey. It was bought by George Clavering, 3rd Earl Cowper, in 1785, and demolished around 1807 to make way for a much smaller stone mansion designed by Samuel Wyatt. It has a portico and entablature with unfluted Ionic columns. In recent years, side wings have been added, and it is now in multiple occupation.

It has had many owners, and during the First World War a published letter records: The Hon. Mrs. Acland, owner of Digswell House, has generously given up her home to convalescent Australians, the house accommodating about 25 officers. Her husband, Col. Acland, is at the front, also her only son, Lt Acland, with the Grenadier Guards. Her eldest daughter is also nursing in France. Truly a patriotic family! The grounds are very extensive, and include a small lake. Plenty of shooting is available for those able to get about. A batch of Australian officers will be leaving Digswell House next week for Australia, two of whom (shot through the stomach) have some way yet to go for recovery.

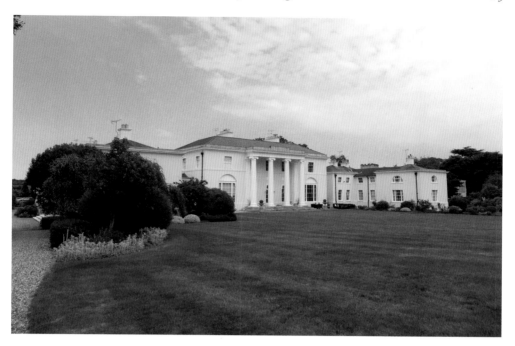

Digswell Conference House, south front.

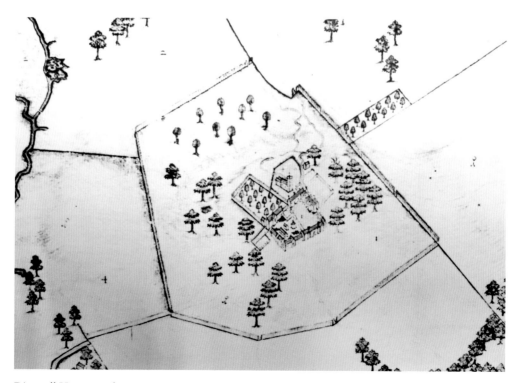

Digswell House on the 1599 estate map.

Col. Acland and his wife were sitting tenants when Ebenezer Howard bought the property and Sherrardswood. From 1928, it was used as a conference centre (local people still refer to it as 'The Conference House'). Later it housed Sherrardswood School. In the 1960s, it was the home of the Digswell Arts Trust, and provided homes and studios for artists until it was sold in 1985 for private development.

Next door to Digswell House is the tiny church, dedicated to St John the Evangelist. It contains interesting brasses of John Peryent, who was standard bearer to Richard II, with his wife, dated 1415, and of John Peryent in full armour, dated 1442. Set into the north wall is a display of late thirteenth-century tracery, which has the appearance of being the top of a west window, but is not explained. The church was until recently supposed to have been founded by Geoffrey de Mandeville in the twelfth century, but examination by the Welwyn Archaeological Society during restoration work strongly suggests an earlier date.

The medieval church became a north aisle by the demolition of the south wall and the subsequent construction of a huge extension in 1962, when the population of the area was suddenly enlarged by the building of the Knightsfield estate. No record seems to have been kept of the original wall or the numerous graves that were obliterated by this extension and its car park.

The house and church and surrounding development are separated from Digswell Lake by Bessemer Road. The lake, which is spring fed, and discharges into the Mimram over a weir, was created as a broadwater for Digswell House at the beginning of the nineteenth century and its surrounds were attractively landscaped. It was rented to a local bailiff, who let out rods for trout fishing. In 1957, after the new Bessemer Road had cut the lake off

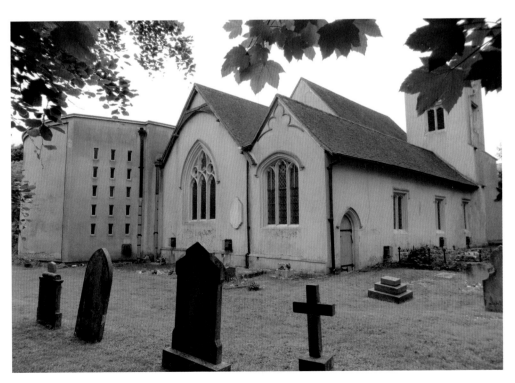

Digswell church, showing the gross extension.

from the neglected park, the Digswell Lake Society was formed. It leased the lake with 17 acres of woodland and ornamental parkland from the Welwyn Garden City Development Corporation. In 1985, the society purchased the freehold of this area from the Commission for New Towns. Members of the society have their own keys and have free access to this attractive area, which is a haven for wildlife.

The northern boundary of the wilderness that lies alongside the lake is Digswell Park Road, the eastern end of which was at the entrance to Tewin Water Park, significantly, because Tewin Water was also owned by the Cowpers, as will be explained later. The western end of the road can be followed behind the new houses on the other side of Bessemer Road. Until the 1960s, when it was obliterated by the new development, it went along the western boundary of the attractive cricket ground, which is next to Digswell House. After that it went south to Sherrardswood, via Monk's Walk.

7

Digswell Viaduct and Digswell Water

Digswell Viaduct

If, instead of turning right into Welwyn Garden City, you go straight on along the Hertford road, you can look down on the Mimram on your right, flowing through pasture. Beside the bridge that carries Bessemer Road, the field contains curious bumps, which are the remains of medieval fish ponds. In the Middle Ages, Christianity forbade the eating of meat on Fridays and at other religious festivals. Fish was not classed as meat, and fish were bred in ponds dug in suitable spots. They were fed scraps, in the same way that pigs were in my childhood. Unfortunately, the owner of the land recently started levelling the field, but not before I had surveyed the fish ponds. My team excavated part of one, finding, among other things, fragments of a large thirteenth-century white earthenware jug. The other earthworks are for a surface-water lagoon.

On your left you pass Station Road. When it opened in 1851, the station was called Welwyn station, although Digswell parish boundary ran along the Up platform. It was

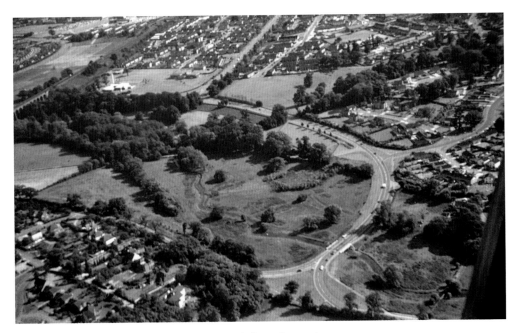

Digswell. Aerial view of the medieval fish ponds from the north.

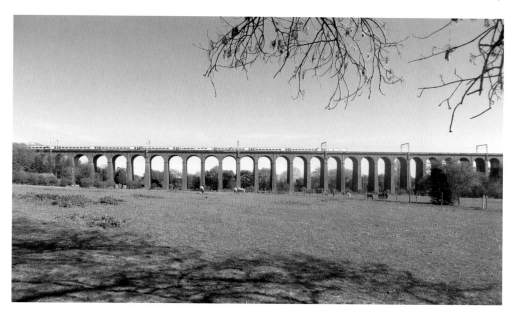

Digswell Viaduct.

renamed Welwyn North when Welwyn Garden City station was opened in 1926, despite its being nearly a mile south-east of Welwyn village. To confuse geographers even further, when the area near the station was developed at the beginning of the twentieth century it was called High Welwyn. Today the inhabitants call it Digswell, but the station is still called Welwyn North.

Above is one of the major industrial monuments of Hertfordshire. People can't even agree about the name of the viaduct. Does it belong to Digswell or Welwyn? They love quoting statistics about its length (1,560 or 1,490 feet?) or its height above the valley (110 or 'almost 100' feet?). They all seem to agree that it has forty arches, but I recommend that the reader should check for himself, because in around 160 years it has probably accumulated more myths and legends than any other place in Hertfordshire.

Until recently, textbooks told of the trench 2,000 feet long and 300 feet wide dug across the valley and filled with burnt clay for the viaduct's foundations, but when I kept what archaeologists call 'a watching brief', looking for potential sites as a new main sewer was laid down the valley, I found no evidence of the trench and no burnt clay. Later in the County Record Office, I found, in a box file, pages from a book, *A Record of the Progress of Modern Engineering*, which had been published only thirteen years after the viaduct was opened. It gave the specifications for oak piles that were driven into the subsoil to support the structure.

In published literature, a lady in Welwyn is recorded as saying that her grandfather employed a gang of men to carry the 5 million bricks made at Digswell Water for the viaduct. The place she specified for the brickworks that made them was actually a gravel pit used by the Garden City Company! Many stories, mostly padding in local newspapers, have added more fantastic details and located other places for brick-making. However, in the Panshanger papers in the County Record Office, I discovered the contracts between Brassey, who built the viaduct, and Earl Cowper, who owned most of the land around. The two enormous parchment documents, which (because they are folded) look like pillows,

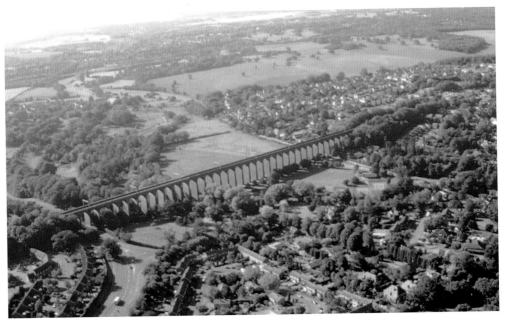

Digswell (or Welwyn) viaduct. Aerial view from the south-east.

tell exactly where the brick earth was extracted – near the modern Welwyn Garden City station. It also tells us that Brassey paid rent and royalties on the bricks and an examination of Earl Cowper's accounts allows us to tot up that 13,975,638 bricks were made between 1847 and 1850 – a lot more than 5 million! But we don't know how many of these were used in building Welwyn (North) station and lining the 4,400-foot length of tunnels, which nobody seems to have taken into account.

Several modern sources, which copy one another, tell us the viaduct was originally opened by Queen Victoria on 6 August 1850, but she was so frightened of heights that she refused to travel across it and the train carrying her had to stop, upon which she entered a horse-drawn carriage to travel across the valley on the ground. She then re-entered the train at the other end of the viaduct and continued her journey. Queen Victoria's own journal records that she was at Osborne on that day. I have been unable to find any record of this event nor any mention of the viaduct in her journals at all.

The viaduct does exist, however. And you can stand to admire the massive structure, count the arches and imagine Blondin, the famous tightrope walker, practising for his feats over the Niagara Falls here. Did he really come here? How could the tightrope have been fastened? I have a fantasy of George Edward Dering from Lockleys pushing Queen Victoria in a wheelbarrow.

Digswell Water

After leaving Digswell Lake, the Mimram goes under the viaduct and runs beside a short stretch of road called Digswell Lane. This is a small part of what was originally a country lane from Digswell Farm (today off Digswell Rise) to Digswell Mill. It ran beside the railway to the Hertford road. In the early Garden City days, it was the main road to Hertford. No wonder the old Garden City inhabitants felt cut off! The old lane has mostly disappeared

Digswell Mill.

Digswell Water. Maran House, once a row of cottages with no centre gable.

in a modern housing estate called Harwood Hill, and been cut by Bessemer Road. The surviving part starts at Bessemer Road and is stopped off at the Hertford road. Beside it is Digswell Mill, which, after ceasing work, was converted into an attractive house. Robin Wells, the son of Henry George Wells (better known as H. G. Wells) lived here, and his father was a frequent visitor. I feel H. G. must have loved staying in the shadow of the viaduct with steam trains thundering around 100 feet overhead.

The area around the mill is today called Digswell Water. The smithy was here and it is likely that this was the hamlet to which the peasants were displaced when Digswell Park was made. The bewildering pattern of the old parish boundaries and the superimposition of modern development, to say nothing of the confused present-day use of place names, makes research an unattractive proposition. Before the railway was constructed there was a lane called Cob Lane, which was almost a continuation of Digswell Lane. It led to Harmer Green via a small hamlet called Cobble (from Cob-Lane) End. It must have been buried under the railway and the north abutment of the viaduct. There is still a small area registered common land called Cobble End Common near Welwyn North station.

From Digswell Water, the Hertford road crosses the river, and at a sharp bend is a timber-framed building with a striking central gable. In the nearby village school, I found a book containing a picture of this very building. The caption told that this was an example of a typical Tudor house. I have in my collection a picture of it taken in the 1930s, when it was three cottages, one of which provided tea for cyclists. There was no central gable at that time.

Lancelot Brown and Humphry Repton

It is easy to look at the landscape of the Mimram valley from Digswell to Hertford as if its attraction is entirely the work of nature, when, although much neglected for nearly 200 years, much of it was the result of careful landscape gardening. Art improved on nature. Lancelot Brown (1716–83) is usually referred to as Capability Brown because, it is said, he would look at the estates of the gentry and pronounce that they had 'great capabilities'. He had worked under William Kent, who was a proponent of a new style of gardening in which formal geometric layouts were rejected and a more 'natural' appearance was contrived on a large scale, with large areas of greensward, planting of woods, and the creation of lakes and carriage drives. We know he worked on Cole Green Park, and it is suspected he might have been involved elsewhere in the county. Something like his type of landscaping can be seen (although it is of a later date) at Digswell Lake today.

Thomas Love Peacock wrote:

> In landscape gardening everything may be called a deception by which we endeavour to make our works appear to be the product of nature only. We plant a hill to make it appear higher than it really is, we open the banks of a natural river to make it appear wider, but whatever we do we must ensure that our finished work will look natural or it would fail to be agreeable.

Humphry Repton had no training as a gardener and had virtually no experience in horticulture, but he saw the capabilities of exploiting his talent as an artist. He coined the expression 'landscape gardener', and started as an exponent of Brown's ideas of 'the picturesque'. He produced books in which he examined the existing 'situation' of parks and sent 'Red Books', so-called because of the colour of their covers, to the landowner, not just analysing what was there and suggesting improvements, but showing them in a practical way by painting sketches of the landscape as it was, with fold-out overlays; remove the

overlay and see the difference! He was very successful and there is no doubt that he had a wonderful talent. We are lucky that we have two Red Books preseved in the Hertfordshire County Record Office: one for Tewin Water and one for Panshanger.

From Digswell all the way to Hertingfordbury, the Mimram valley was owned by and landscaped for the Cowper family. In 1799, Repton wrote, in the introduction to his Red Book for Tewin Water:

> The whole of the beautiful Mimram Valley from Welwyn to Hertford, including Digswell, Tewin-Water, Panshanger and Cole Green, belonging to the same noble family will give each of the places a degree of extent and consequence which it could not boast exclusive of the others, and while each possesses its independent privacy and seclusion, their united woods and lawn will by extending throu' the whole valley enrich the general face of the country.

8

Tewin Water to Marden

Tewin Water

After Digswell Water, the Mimram flows into the estate of Tewin Water House. It is interesting that Drury & Andrews' map has two names as owners: Lady Cathcart and Joshua Steele Esq. Why two owners? Thereby hangs a tale, or rather a series of tales. The daughter of a Southwark brewer married James Fleet, the owner of Tewin Manor. He died in 1733, and she inherited considerable property. She next married James Sabine, who rebuilt the manor house, but died in 1739. Of course she was quick to remarry, her choice being Lord Cathcart – who died shortly after. 'My first marriage,' she is reported to have said, 'was to please my parents. The second was money, the third was for a title and the fourth because the Devil owed me a grudge.'

Her fourth choice was Hugh McGuire, an Irish officer who had served in the Hungarian service. She was fifty-seven, he was forty. By a subterfuge, he carried her off to his castle in Ireland, where she was locked in a large guest room in solitary confinement. Nobody dared to try and save her because McGuire was a successful duelist. His guests had to drink to her Ladyship's health, while he told his servants to ask if she required anything. They always replied that she had everything she wanted. Eventually, she made over all her property to him.

In 1766, he either met a duelist better than he, or cut himself with his penknife and died of tetanus. He may even have been looking for treasure in Tewin Water House and trying to open a cupboard with the pocket knife. In any case, Lady Cathcart escaped. She was dressed in rags and wearing an old red wig over her long grey hair. Seemingly bewildered by being greeted by the very people who had neglected her plight, she packed and returned to Tewin, where she then spent twenty-five years recovering her property. At the time the map was made, she had to evict Joshua Steel, to whom McGuire had granted a twenty-one-year lease.

She was seventy-four when she returned from Ireland. Carrington's diary records that for twenty-three years after her return she danced at routs and assemblies. 'It is woeful,' wrote Horace Walpole, 'to have a colt's tooth when other folks have none left.' She was 'in a good state of helth and retaining her senses considering her great Age and receeve Company & ride out in her Carriage till within one month of her Death … on the Fryday morning following the 3rd day of August 1789, aged 98 years.' Inside her wedding ring, it is alleged, was the inscription: 'If I survive, I'll make it five.'

From Digswell Water, the Hertford road runs almost straight for nearly a mile. Twenty years ago, this was the only stretch of the otherwise winding road where the motorist could get up speed, and it was all due to Repton, who shifted the road to make room for Tewin Water Park. You can get a glimpse of Tewin Water House through the trees on the left, among which is hidden a small mound that was probably once crowned by a tholos temple, which was a feature suggested in one of Repton's pictures. The south side of the road is overshadowed by

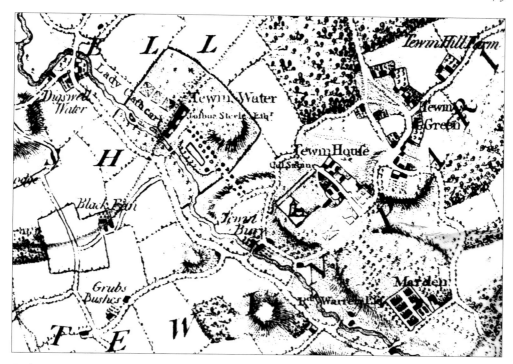

Andrew & Drury map, with Tewin Water, Tewin House and Marden. Note the proprietors' names at Tewin Water.

Welwyn Garden City housing, at the south end of which is Crookhams, where there was a Belgic farmstead. Its ditches, which contained a surprising quantity of pottery, were exposed by the foundation trenches of the houses and investigated by my team in the early 1960s.

A new road, called Waterside, comes down a dry valley from the south and joins the Hertford road. Before the Garden City was built, there was a small hamlet here called Black Fan (from, I suppose, 'fen'), the site of which is now under a large rainwater lagoon. On the west side of the valley, the Welwyn Archaeological Society found a crop mark in a field called Nutfield, which is now part of a golf course. Excavation found it was another Iron Age farmstead. Crookhams is in sight across Black Fan valley. Near Nutfield is Daniels, where we found another ditched enclosure, and the so-called Panshanger chieftain burial.

Tewin Water became an addition to the Cowper estates. Lady Cathcart's house was pulled down and a new one was built. This was occupied by Lord Townsend, a relation of Lord Cowper. In 1798, Henry Cowper, brother of the 7th Earl, built the present elegant neo-Greek house, which was designed by John Groves to incorporate part of Townsend's. Repton admired the way in which this work was done, despite having to adopt the original floor levels.

This makes me wish that I had been consulted at an earlier stage in the business or at least before the water had been penned up so high as to give his house the character of dampness: so that nothing already done might have required alteration: this however will not I hope be attended with so much trouble as to make it a serious inconvenience when we consider the improvement both in point of view of beauty and convenience.

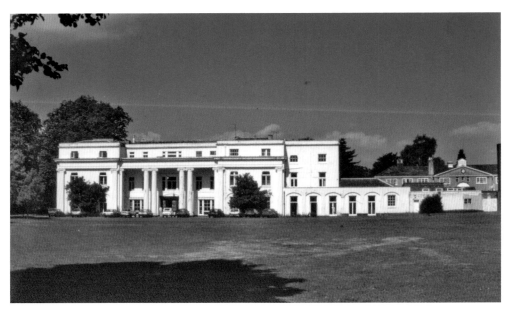

Tewin Water House. East front.

In the grounds he began by judicious felling of the avenues and rows of trees, making lawns and planting new trees: 'groups of trees or masses of wood' to 'flow beyond the hill and have no apparent boundary'.

> Secondly the restoring of the water to its original level and character, making it evidently the rattling trout stream of Hertfordshire fretting over its bed of gravel rather than appear an artificial canal in a clay soil – the natural river which drains the meadow instead of the penned up dike that poisons them and converts the fine meadow into a swampy bed of rushes.

He still thought that a lake was essential to a park. The new lake he created is some way from the house, at the corner where Churchfield Road from Tewin meets the Hertford road.

There were many distinguished tenants of Tewin Water House after Henry Cowper died. Perhaps most noteworthy were the Beit family. Alfred Beit, who had become an authority on the diamond market in Amsterdam and then spent twenty-seven years in South Africa developing the Kimberley diamond mines and the Rand goldfields, was reputed to be the richest man in the world. He never married, and the tenancy passed to his brother, Otto (later Sir Otto), who bought the estate from the Cowpers. He died in 1930 and his son, Arthur, inherited the estate and the baronetcy. He married in 1939, and died in 1994; Lady Beit died in 1946. The estate became a country club, then had other tenants, one of whom felled many of the trees planted by Repton. In 1953, the estate was compulsorily purchased by the county council, which sold much of the land, and more of the surviving woodland was felled. In 2000, the county council sold their part of the estate. The house is now divided into separate apartments, and a small housing development has been constructed on the west of it.

 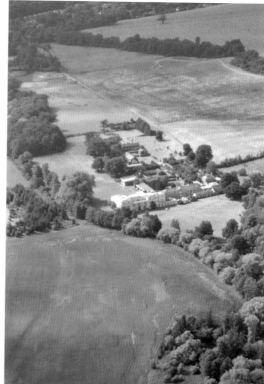

Above left: Tewin Water. Cataract of artificial stone by Pulham.

Above right: Tewin Water. Aerial view from the east.

I was taken by a friend to make an aerial survey of the Mimram valley in 1989. I wanted a low altitude view of the house. My pilot asked permission from air traffic control at Panshanger airfield. They gave permission but insisted that, since there had been complaints about noise, he should glide. Mission completed – the engine refused to start!

Ahead of us was Digswell Viaduct and there was little room for manoeuvre. Luckily, my pilot solved the problem. We lifted over the viaduct, and I muttered to the pilot, 'Did you know that that is a school for the deaf?'

After it leaves Tewin Water's lake or broadwater, the Mimram flows past the east lodge and goes under a bridge, which carries Churchfield Road. It then goes through a marshy area of tall thatchers' reeds that was once an unpleasant pond of effluent from Welwyn Garden City's sewage farm, but is now a nature reserve of the Herts and Middlesex Wildlife Trust. It then passes Tewin Bury Farm, now a luxury hotel and a place for wedding receptions, corporate meetings and conferences.

Down the road below the farm is an area fed by springs and covered in woodland, beside which is the curiously named King's Bridge, where there appears to have been a ford, now overgrown. This is probably where the lane from the vanished Tewin village came out to join the Hertford road. Beside this is a modern fish farm, which is reminiscent of the medieval fish ponds we met at Digswell.

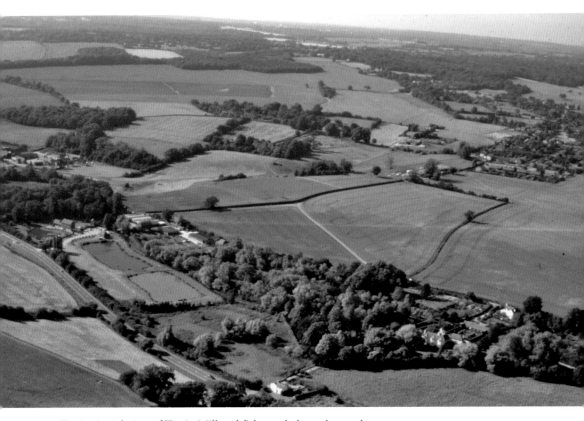

Tewin. Aerial view of Tewin Mill and fish ponds from the north-west.

Many years ago, I was conducting an extramural class from Tewin on landscape history in the field when some students drew my attention to a difference between the eighteenth-century estate map that I was using and the actual state of affairs on the ground. Today there seem to be two Mimrams. We investigated. One Mimram was a diversion to take the main flow close to a barn from which a roofed structure projected. We deduced that it once housed a waterwheel. It was not a mill, Carrington's diary explained:

> Tusday 21 Novr 1809 … to See Mr Deacon, the farmer their, the alteration he is making by turning the River by his Wheat Barn through the farme yard for a thrashing meshean by water. Saw the Bridge Building to X the River in the farme yard and Saw the Great Elm tree felled near the House to make the wheele of 3 load of Timber or more, it Looks to me more then the Thrashing, a little Time will Shew.

There were at least three successive Tewin Houses. The last and most impressive was the one built by Sabine in 1716–18. It was sold by the Sabines to Robert Mackay, who sold it to Charles Schrieber. When his son William died, it fell to the empire building of the Cowpers. Carrington's diary records that at the end of June 1807:

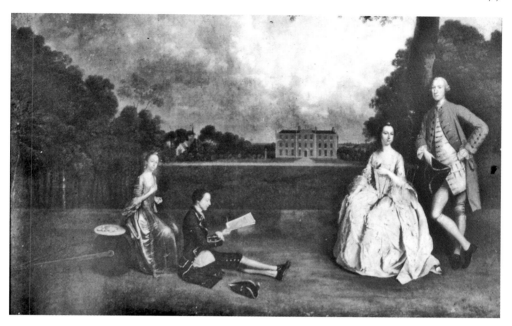

The Sabine family with Tewin mansion and church in the background.

Tewin. The church is on the left. The cellars of the house, shown in the picture of the Sabine family, are in the centre where the fence dips down.

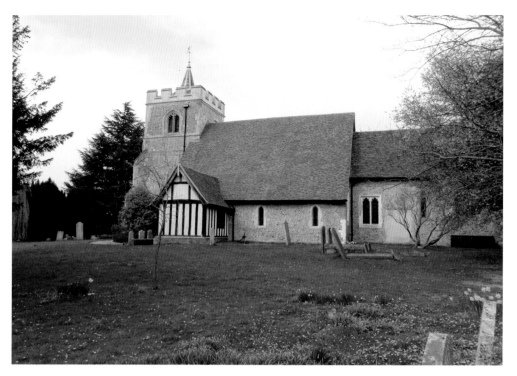

Tewin church.

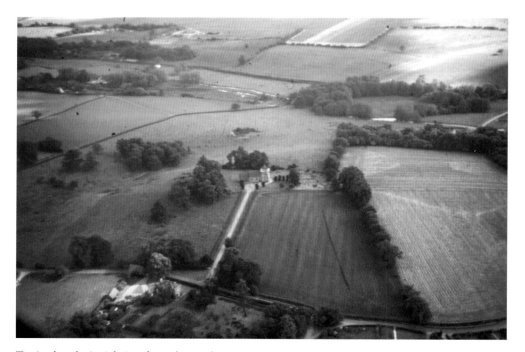

Tewin church. Aerial view from the north.

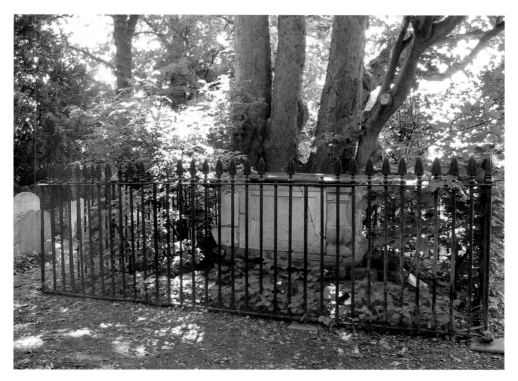

Above: Tewin. The grave of Lady
Anne Grimston.

Right: Tewin church. Monument in the
porch to Joseph Sabine.

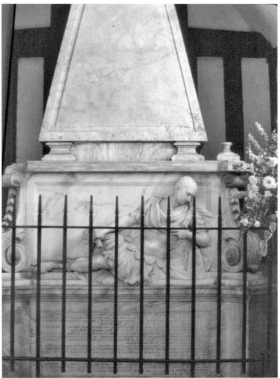

This month Begun pulling Down Tewin Great House by the Church the offices all down the 2 Last months past, kitchen, Brewhouse, Laundry &c. Stables, Coach House &c. &c., the mantion House 3 Story High besides the offices & below the whole Bredth of the House, with fine Lofty Rooms & the Grandest Stair Case alloed to be in England, 27 Widows East front 27 in West front & 9 in Each end, fine large sashes, all Brick with Large Corner Stones, flat Roof with Ernes Standing all Round at the top.

Today you can see a depression in the field to the east of the church drive. This is the location of the cellars of one of the grandest houses of its period in Hertfordshire. The 5th Earl Cowper paid £35,000 for the estate of 860 acres. He demolished the grand house and never replaced it. As we have already discovered at Digswell viaduct, Earl Cowper's family were keen on counting things. He did recover 14.5 tons of lead, 909,100 bricks, 35,000 tiles and 11,187 paving tiles, which were used in the building of the new Panshanger House. Ironically, that too has disappeared, as we shall discover later.

Tewin church, St Peter's, stands alone above the farm and is reached from the road by a long, hedged drive through the fields. The explanation of its isolation is that this is another migrated village, like Digswell. Tewin House was beside the church. One of its owners, probably Joseph Sabine, must have decided on emparkment and expelled the peasants. Of course they had to have access to the church, hence the long drive.

Several tombstones and monuments are worth visiting. A large monument to Joseph Sabine is in the church porch. It depicts him dressed a Roman general. Lady Anne Grimston is buried in the churchyard. It is said that she denied the possibility of resurrection and after her burial, a great tree burst her tomb asunder. You can see it to this day.

Tewin Mill

My wife and I once spent a lovely summer day, by kind permission of Dr and Mrs Knight, paddling in the river on the site of Tewin mill, which had been demolished in 1911. We were looking for glass. The reason for this enjoyable search was a clue in Carrington's diary of 1804, when he went to the funeral of Robert Gass:

> He was Brot from London by one Thos. Righbright an Optision about the year 1760, Who Took Tewin Mill which was a Corne Mill and at a Great Expence Altered it into a Glass Mill for polishing Convix and Concave Glasses and Spicticles Glasses &c &c and no addmittince for any to see the Same for Maney years … in the year 1803 it was taken by one Cannon of Wellwin and made a Corne Mill again after upwards of 40 years a Glass mill.

We were looking, unsuccessfully, for physical evidence and for amplification of this strange story. For example, was the glass sent to Tewin in ready-made blanks? Other questions could not have been answered by our aquatic archaeology, such as, where did the glass come from?

The back garden of the mill house is a private arboretum, and on the opposite side of the river is an 'unimproved' meadow, which the Bartons of Warrengate Farm have deliberately not spoiled by the addition of artificial fertilisers, weed killers or special grasses. It is especially beautiful when the buttercups are flowering – a sight not often seen as a result of modern husbandry.

Downstream, on the other side of the lane that comes down from Tewin, there were watercress beds at the small settlement of Archers Green. The 'modern' Fletton-brick building behind it was built in 1910 as a model dairy. The old barn, a tithe barn, was moved there at

Tewin. Map of *c.* 1840 showing the river divisions for Bury Farm (147) and the Mill (194).

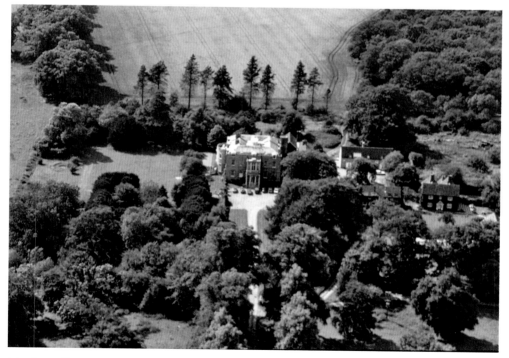

Marden Hill. Aerial view from the east.

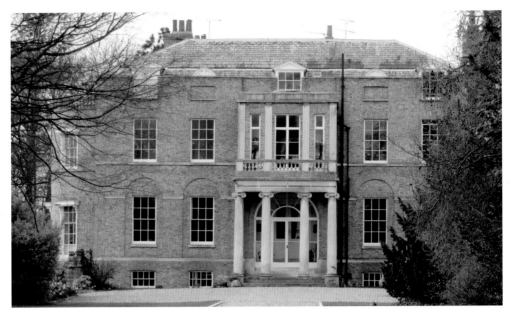

Marden Hill. East front.

the same time from Marden Hill farm, the pieces having been numbered so that it could be reassembled accurately. It has been converted into a dwelling house in recent years.

Half a kilometre further downstream, a public footpath gives access to the floodplain and the 'unimproved' wet meadows are probably the most rewarding part of the valley to anyone interested in natural history. Ivor and Vaughan Williams of Tewinbury have designated it as Public Access Land, where you can enjoy the ecological diversity of a chalk stream, typical of the environment of my own childhood. The footpath is on the line of the drive to Marden Hill. It goes over a bridge beside which is the hydraulic ram, which pumped water up to the house.

Marden Hill

In 1550, the Manor of Marden paid rent of 26 ounces (about 900g) of honey to the abbey of St Alban. Marden was held by the abbey until the dissolution, and in 1539 it was granted to William Cavendish. It came to Edward North, Master of Harriers to Edward VI. In 1653, his grandson demolished the Elizabethan building and built a new house on the site of the present one, Marden Hill, high above the Mimram. After several owners, Robert Macky demolished all but the present north wing in 1789 and joined that to an elegant Georgian house. It was bought by Richard Flower and became the meeting place of many men of 'radical and dissenting opinion', including William Cobbett.

In 1817, Marden Hill was sold for £23,000 to Claude Thornton, who commissioned Sir John Sloane to design a vestibule and staircase, but who also added the Ionic-columned two-storey porch that is a notable feature of the building. In 1903, it came, at last, to be owned by the Cowper estate, and was leased. During the war, it was occupied by a boarding school. In 1957, it was owned by a gravel extraction company, which was unable to demolish the listed building, and leased it to two architects, who signed a twenty-one-year lease. A co-ownership company was formed, which now owns the freehold of the Marden Hill. Nine families live there today.

9

Panshanger

Panshanger

My first experience at Panshanger was a very strange one. My wife and I had just arrived in Welwyn Garden City and we were like cats exploring our territory. We came to Poplars Green, where the spring air was rich with the spicy smell of balsam poplars, and entered the neglected park through a gate beside the lodge, where a footpath was signposted. We quickly went 'off-piste', hoping to get a look at the great house marked on our map. Quietly, and apprehensive of being caught by keepers, we walked up the overgrown drive through the trees, turned the corner and – there was nothing there. Creepy!

Some years later, I was very involved in my self-imposed task of discovering and rescuing archaeology as it was being dug up by developers as Welwyn Garden City expanded, but I still found time to explore. Near Panshanger airfield, I made an unexpected find. A deep but overgrown ditch beside the road in the park continued in the field opposite, but was less obvious because of ploughing. It must have been an enclosure of some sort, and was about the same size as an Iron Age farmstead. Could it be a survival from before the Roman occupation? Dr Ilid Anthony, the director of Verulamium Museum, came out to meet me on the site. She was a very talkative lady, and I was unable to stop her chattering as we pushed our way through the undergrowth; I hate being caught by keepers when I am trespassing in pheasant coverts. We weren't caught, but we didn't solve the puzzle.

Eventually I found an old map, which showed me that my Belgic ditch was actually the site of Cole Green House. More research followed. The house was built here for the 1st Earl Cowper (great-uncle of the poet William Cowper) at the beginning of the eighteenth century. It was a fine, four-square brick-built house overlooking a beautiful park. In 1756, the 2nd Earl employed Capability Brown to landscape the park. Brown had surrounded the house with a ha-ha, a fence or wall hidden in a ditch so the barrier was invisible but animals could not stray. The ditch can still be seen, but Cole Green House has disappeared.

The Cowpers had royal connections. The 1st Earl was married to Mary Clavering, who was Lady of the Bedchamber to Caroline, Princess of Wales. The 2nd Earl was Lord of the Bedchamber to George II, as well as Lord Lieutenant of Hertfordshire. His heir, George Nassau Clavering-Cowper, was MP for Hertford from 1759–61, but after he succeeded to his father's estates and titles he mainly lived abroad. He collected a mass of works of art and spent most of his later life in Florence, where he died in 1789. His elder son George Augustus Clavering-Cowper was underage and his estates were held in trust until he was twenty-one, but he died, unmarried, at twenty-two. His brother, Peter Leopold Lewis Francis, thus became the 5th Earl in 1799. We have already met him as the person responsible for the demolition of Tewin House. Panshanger, under the 5th Earl, was famous for lavish entertaining and culture 'full to the brim of vice and agreeableness, foreigners

Panshanger. Modern view from the same location as the nineteenth-century print.

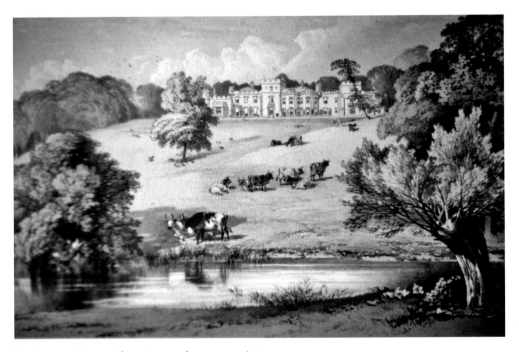

Panshanger House. A late nineteenth-century print.

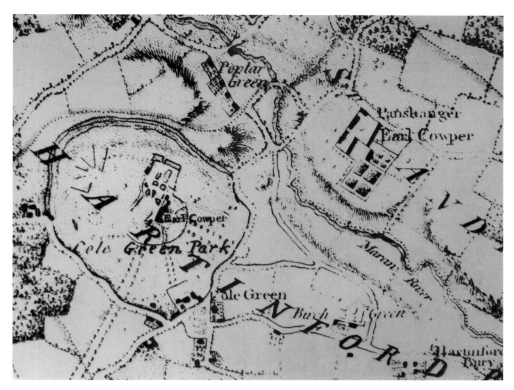

Andrews & Drury map showing Panshanger and Cole Green House.

and rues'. The estate grew, sometimes to the despair of its lesser neighbours, as Carrington sadly records in his diaries, who lost their holdings by means fair or foul. After Peter died, his wife, Emily, married Lord Palmerstone, who was twice Prime Minister and lived at Brocket Hall, near Lemsford. Eventually, the Brocket estate passed into the ownership of the Cowpers, and it remained so until 1922.

The fortunes of Panshanger changed at the beginning of the twentieth century. The 7th Earl died in 1909 and his wife, Katrine, died in 1913. The estates were inherited by Ethel (Ettie) Priscilla Grenfell, a niece whose husband, William, had been created 1st Baron Desborough of Taplow. He and his wife lived both at Panshanger and at Taplow Court in Buckinghamshire. In the First World War, Taplow Court was a rest home for nurses.

The Desboroughs had three sons and two daughters. The elder sons, Billy and Julian Grenfell (the war poet), were both killed in the First World War. Land was sold off. Some 1,458 acres was bought in 1919 by Ebenezer Howard. That is where the town of Welwyn Garden City was built. The Desboroughs' third son, Ivo, died in a motoring accident in 1926. In the Second World War, Panshanger was a home for young mothers. Lord Desborough died in 1945. Ettie died at Panshanger in 1952.

Panshanger suffered the fate of other country houses along the Mimram; social change had made them a liability. In the 1911 census, Countess Cowper lived there with two nieces and had two visitors. In addition to the gardeners, bailiff and keepers, and other servants living on the estate, in the house there was a butler, a footman, a housekeeper, a cook, two ladies' maids, three housemaids, two laundry maids, a scullery maid, a still room maid,

two laundry maids and an 'odd man'. Soon most of the wealthy families with large retinues of servants ceased to exist.

My wife and I had arrived eight years too late even to see the house. Just as Tewin House had been demolished to supply building materials for Panshanger in 1807, Panshanger had been levelled in 1952 to be democratically distributed by auction, to be recycled or to be used as hardcore for the masses.

Panshanger Park

The 5th Earl Cowper called upon Humphry Repton, who produced one of his Red Books in 1800. He was starting from scratch; the site, apart from the area round Cole Green House, which was landscaped by Capability Brown, was farmland in separate holdings until the late eighteenth century, and was divided by hedges.

Repton decided that the landscaping should begin with deciding where to put the house. This makes for fascinating reading, especially when visiting the site. Reference should be made to made to the illustration taken from the Red Book.

The natural character of the surrounding Country
The chief beauty of the Estate consists of the Valley, or rather the two hanging banks which form the Valley, because the summits of the Hills on each side are flat, or what is called Table Land; and unless the House were to stand very near the Edge of the slope, it would command no View of the Valley; this is the Case with respect to the present Mansion at Cole Green which stands so far back on the Hill as to make the views from it appear flat and uninteresting. It was I believe once proposed to bring the house forward toward the Brow, B, of the same valley, this spot commands the most ample View, but its aspect would have been to the North, and much of the Landscape would have consisted of land which does not belong to the Estate: either of which circumstances would be sufficiently objectionable, since in this climate the aspect or exposure of the principal rooms should be the first object of consideration; and the power we have over all the Ground seen from the House is not of much less consequence: since both the Beauty and the Convenience of the Situation depend more on what is seen from the house than the actual extent of the property; and it is better to have a Neighbour at less distance behind a house than to see a great house though much farther yet within such a distance of the front as tend to destroy the Unity of property, and of course lessen the importance of the Place.

In that delightful Valley which extends from Hertford to Welwyn there is no part more beautiful or interesting than the Ground near the present House at Panshangre, C, and therefore at the first View of it, we should pronounce that a house cannot be better situated, but the beauty of this view is very confined, and is only seen along a narrow Dell which falls into the valley at right angles: of course it would hardly admit a house of twice as large as the present, unless it were brought lower down the Dell, and I this confess was my first idea for the situation at D. I therefore considered that the Water would produce nearly the same effect from both stations, and would be well placed both with regard to the present house and to a new one built in the same line. But when I reflected that the present Pleasure Ground might be rendered equally interesting to a new house, it seemed unpardonable to choke up the mouth of the small Valley or Dell by placing a house directly across it, and this determined me to seek another situation. The top of the hill is as flat as the table land on the other side of the valley, with the additional objection that the slopes being planted we would not

see into the valley without cutting down the wood, and therefore I am compelled to seek a situation below the wood, either to the East or west of the Dell or short valley already mentioned

The Aspects or Exposure

If it were possible in all cases to fix a house as I should wish, I should asset that the best aspect for the principal Rooms is due South or rather a few points towards the East for various reasons: first the South Sun is cheerful in winter when it is low in the Horizon, and in summer it is so much elevated as seldom to be troublesome: secondly the view from a large house should consist of wood, Water and Lawn, all these objects appear best with the light behind them, and thirdly the ornamental parts of the Architecture are in a great degree lost in the North front of a house, which is never lighted up by the sun; and though I have seen Grecian Porticos so placed, yet a Portico to the North is absurd; because both useless and invisible at a little distance while the front towards the South is strongly relieved by light and shade during every part of the Day and there is no object more beautiful than a large building illuminated

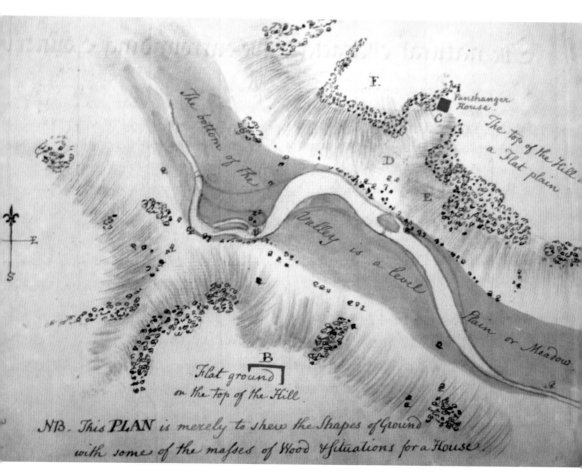

Panshanger. Humphry Repton's sketch map for the location of the house.

by the rays of the sun and contrasted by rich hanging Woods in which it appears to be embosomed and surrounded.

If the aspect is to be consulted, we are under the necessity of fixing some aspect across the valley which runs from West to east, and this brings us to some situation near the House at Panshanger C.

'A' is the site of Cole Green House, already mentioned in my account, and easily located on the ground. 'C' is the site of the original Elizabethan Panshanger House, approximately at the same location is the present stable block. 'E' was the site chosen. The remains of its basement level can still be seen on the ground and found on the Google satellite map.

Repton offered designs for both a Grecian (Palladian) house and a Gothic one. Neither of these was actually built. It is remarkable that, unlike the other Cowper houses in the valley – Digswell and Tewin Water – the one that was built here, and was started by Samuel Wyatt in 1806/07 and completed by William Atkinson from 1806–20 was Gothic.

When my wife and I first visted Panshanger Park over fifty years ago, we were trespassing. It was owned by a gravel extraction company and maintained for pheasant shooting. We even found an ominous notice: 'WARNING. GUARD DOGS UNDER TRAINING'. The mind boggles. Eventually, in 1982, planning consent was given for the extraction of gravel on the undertaking that when the work was completed the land would be turned into a public park by the owners. The restoration is now proceeding, and at the end of March 2014 the eastern half of the park, about 200 acres in extent, was opened. A car park has been provided at Thieves Lane, which is off the A414, and access land, permissive footpaths and a cycle track have been waymarked. Lafarge Tarmac are to be congratulated on the restoration and a visit is highly recommended.

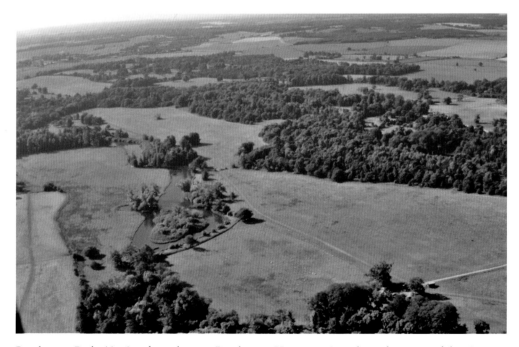

Panshanger Park. Air view from the east. Panshanger House was just above the centre of the picture.

Today, Repton's tree planting can be made out, overgrown and much neglected. His lakes are now clearly visible, since gravel extraction has cleared and deepened them. On a modern map, the outline of the park is easily discerned as it is framed by roads (if you ignore the new A414).

Map of the eastern end of Panshanger Park, which was opened to the public in 2014. (*Reproduced by kind permission of Lafarge Tarmac Ltd*)

10

Hertingfordbury

Hertingfordbury

The Mimram leaves Panshanger Park and goes under the new A414 and then through the village of Hertingfordbury, a quiet place since the A414 bypassed it. There are many interesting buildings in the village, including a mill, now converted into dwellings, and Epcombs, which a local lady assured me was the home of Jane Austen's Bennet family in *Pride and Prejudice*.

Hertford is recorded (as Hereotford, which meant 'the ford of the stags') as early as the seventh century. In 912, the Anglo Saxon Chronicles record:

> After Martinmas King Edward commanded the northern burgh at Hertford be built between the Maran and the Beane and the Lea. And then the summer after that… Some of his force wrought the burgh at Hertford on the south side of the Lea.

Hertingfordbury Mill.

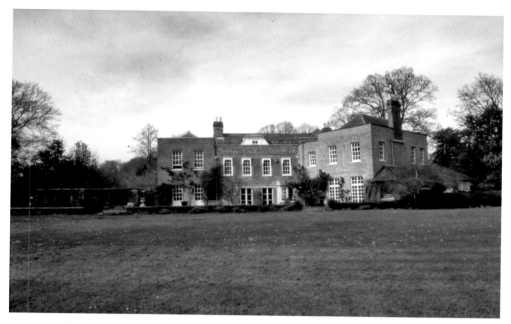

Hertingfordbury. Epcombs.

This poses a geographical problem. One of the Hertford burghs must have become the site of Herford Castle, which was built by the Normans. Where was the other?

A possible candidate for its location might seem to be in Hertingfordbury Park, since Hertingfordbury was earlier called Hertingbury and *is* between the Mimram and the Lea, although the Beane joins the Lea much further downstream. A 'burgh' was a fortified place. In the Saxon period, it might have consisted of earthworks or timber. Later the term, now 'bury', was used for any fortified house, and by the eighteenth century it was applied to give status to any large house. There are no traces, however, of any fortified stronghold at Hertingfordbury.

Hertingfordbury Park, about 200 acres in extent, is first mentioned in 1285, when it contained 150 deer. It was part of the manor, which belonged to the King as Duke of Lancaster. Henry VIII and Elizabeth I hunted there. Its boundaries were the Mimram, the Lea and fences. Unfortunately, parks, like large country houses, become obsolete. At one time they were status symbols – signs of conspicuous consumption. The owner could dedicate land to unproductive deer, rather than profitable barley, wheat, beans or common cows. The original parkland here has disappeared. In 1850, the Welwyn–Hertford railway went right behind the house, almost on the line of a ha-ha, bisecting what must have been the park. The railway was closed in 1964 by Dr Beeching and is now a pleasant bridleway. Although land was purchased in 1898 for the Hertford loop (Stevenage via Cufley), which was intended as a diversion in the event that Digswell viaduct or Welwyn tunnels became obstructed, it was not built until 1910–20. It cut off the eastern side of the park from the Lea. In 1945, a sale of the Bayfordbury estate divided the park into a number of separate lots.

In 1619, Hertingfordbury was sold to Thomas Keightly. His grandson, Thomas, sold it to John Cullen, a London merchant, in 1681. He built 'a very fair house' there, with walled enclosure, stables and a farm. In 1720, it was sold to Spencer Cowper, who passed it to

his brother, Lord Cowper. Surprisingly, in view of the Cowpers' later acquisition of land in the Mimram valley, the estate was sold to Richard Baker in 1757, and became part of the Bayfordbury estate. In view of later events, it is surprising that it wasn't available to be added to the Cowper 'empire', which eventually, as we have seen in earlier chapters, stretched from Hertingfordbury to Digswell. John Cullen's house was demolished in 1814, shortly after Bayfordbury was built. St Joseph's School was built near its location in the early 1950s, and incorporated some of the garden buildings.

An L-shaped building shown in early maps of the park is probably of Elizabethan date. It was later the home farm. It was incorporated into a house with Dutch gables in 1906. The original work can be distinguished by the narrow, pre-tax bricks. In 1784, a tax was imposed on bricks. As it was paid per brick, the makers increased the thickness of bricks! A matching Dutch-gabled gate house or lodge was also built near the church in 1906. Bricks were made from local brick earth; a brickyard appeared on the 1773 map, and the brick earth was exploited on the east side of the railway until the 1930s. The red-brick building became a convent in 1949; in 1986, it became a nursing home. It is now divided into private dwellings.

Hertingfordbury church, dedicated to St Mary and St John, stands on a prominent site, which has been suggested as that of the original burgh. Unusually, the advowson, or right to appoint the rector (priest in charge), is held by Her Majesty the Queen, in her persona as Duke of Lancaster. Like St Mary's Welwyn, the church has been virtually rebuilt, giving

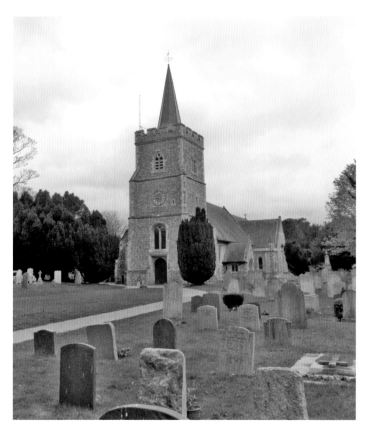

Hertingfordbury church.

the impression that it is a Victorian structure and, as at Welwyn, the various monuments, many of which are of great interest, have been moved from their original places, probably to provide space for, or to be put into, the Cowper chapel or mausoleum.

Possibly the most notable monument is that of Spencer Cowper, Judge of Common Pleas, who lived at Cole Green House. The highly admired sculpture by the famous artist Roubiliac shows Spencer seated between Wisdom and Justice. Justice seems to be challenging Wisdom. There is a certain irony in this monument. Spencer was the son of the Lord Chancellor and, as a young man, was a barrister on the Home Circuit in March 1699 when he went to deliver a payment for a mortgage to the Hertford home of Sarah Stout, who was apparently infatuated with him. Evidence was given that he was expected to sleep the night there, but when the servant, who had gone to warm the bed for him, came downstairs, both Spencer and Sarah had gone out.

The following morning, Sarah's body was found floating by the mill dam. There was a groove round her neck and a bruise about her ear, and her clothing was disarranged. In July 1699, Spencer was tried with three other lawyers and conducted his own defence. Expert witnesses were called, who testified that a person who had drowned would sink and that Sarah must therefore have been dead when she entered the water. It was concluded, however, that she had committed suicide. Spencer and his fellow accused were honourably acquitted. He resumed his practice at the Bar, became an MP and, as a judge, 'presided over many trials for murder, ever cautious and mercifully inclined, remembering the great peril which he himself had undergone.'

In the churchyard is the unmarked grave of Jane Wenham, who is often said (incorrectly) to have been the last woman to be condemned as a witch. She lived at Walkern and by all accounts behaved in a crazy manner. As a result, she was accused of causing a servant at the parsonage to have fits. Sir Henry Chauncy, a magistrate and a historian of the county, along with the rector of Walkern and the vicar of Ardley, took her into custody. She was persuaded

Hertingfordbury church, the Spencer Cowper memorial.

Hertingfordbury Park. The Hertford viaduct.

to make a vague confession and was brought before Hertford Assizes, which were crowded with spectators, in March 1712. The evidence, which we might think of today as incredible nonsense, was found to be overwhelming. She was condemned but reprieved.

She was allowed a small pension by the Earl and Countess Cowper, and lived in a cottage at Hertingfordbury. At her funeral in 1730, a sermon was preached 'to a numerous congregation'. A war of pamphlets then kept the memory of her case alive, and the death penalty for witchcraft was abolished in the Witchcraft Act of 1753. A year in prison and a quarterly appearance in the stocks was substituted. Ninety years later, the Rogues and Vagabonds Act abolished the crime of witchcraft, but 'every person pretending or professing to tell fortunes, or using any subtle craft' was to be condemned to three months hard labour. This conveniently seems to have been forgotten.

After Hertingfordbury Park, the Mimram goes under the viaduct that carries the Hertford Loop Line. Then it flows between a very neglected area of marshy floodplain that contains Hertford football ground on one side and rough pasture on the other, before meeting the River Lea. The junction is unspectacular; actually the Lea joins the Mimram at right angles, but geography calls their combined waters the Lea.

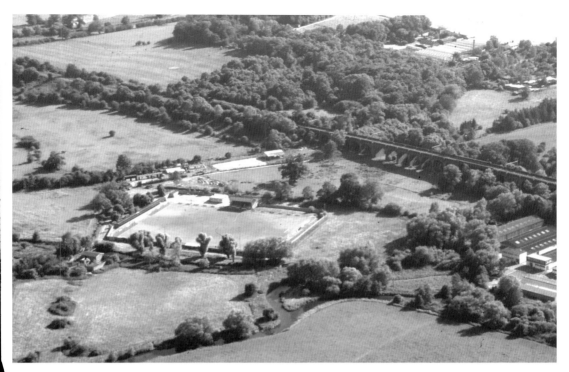

The confluence of the Lea and Mimram. Aerial view.

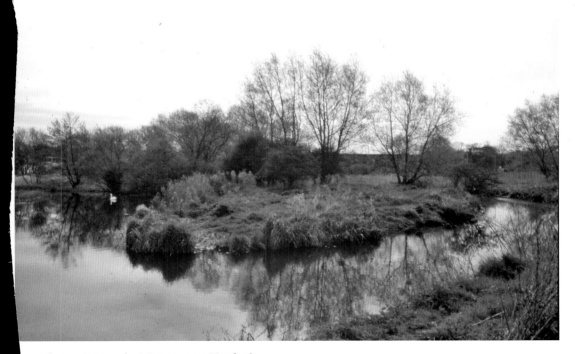

The Lea joining the Mimram near Hertford.

Acknowledgements

My memory is so bad. I forget people's names, I make lists and then mislay them and, because so many people have contributed in some ways to this book, I feel reluctant to try to name all of them. I assure you that if I have left you out it doesn't mean that I am not grateful!

Thank you, then, to: Mary Arikoglu, Harry Bott, John Bright, John Catt, Dr and Mrs Knight, Lottie Clarke, David Cheek, Ben Cole, Clare Lewis, Hugh Howes, Paul Jiggins, Gary O'Leary, Roger Marvin, Adrian Toole and Jon Wimhurst. Thanks also to the friendly staff of Hertford and Mill Green Museums and HALS. Also, to members of the Welwyn Archaeological Society and members of my adult evening classes: *Homines dum docent discunt*!

Special thanks to Nick Tracken, who read the book in draft and did a lot of much-needed editing. The mistakes are all my own.